MASTER CLASS PHOTOGRAPHY SERIES

BETTER BLACK-AND-WHITE DARKROOM TECHNIQUES

Bob Casagrande is best known for the wide range of ingenious darkroom effects he creates in his black-and-white fashion photography. In the United States his work has appeared in *Family Circle* and other magazines; in Italy his photos have been featured in *Lei, Abitare*, and *Vogue Italia*. After studying photography in Italy, France, and Belgium, Mr. Casagrande received his B.S. degree from the Rochester Institute of Technology. He mastered his craft as a studio assistant to famed Italian photographer Giuseppe Pino, and has also been the technical director of the Olden Photography Workshop in New York City.

The Master Class Photography Series
Better Black-and-White Darkroom Techniques
Creative Still Life Photography
Improving Your Color Photography

MASTER CLASS PHOTOGRAPHY SERIES

BETTER BLACK-AND-WHITE
DARKROOM TECHNIQUES

Bob Casagrande

A SPECTRUM BOOK

Prentice-Hall, Inc.
Englewood Cliffs, New Jersey 07632

A Quarto Book

Text copyright © 1982 by Quarto Marketing Ltd.

Photographs pages 10, 20, 60, 61, 73 top and bottom, 74, 84 left
and right, 119 top and bottom, and 120–121
 Copyright © 1982 Michael Wade Blatt
Photographs pages 12–13, 14, 18, 19, 21, 32–33, 39, 42–43, 46, and 47
 Copyright © 1982 Guiseppe Pino
Photographs pages 16–17, 22, 24, 31, 36–37, 38 and 44
 Copyright © 1982 Joseph Heptt
Photographs pages 24–25
 Copyright © 1982 Ann Brandeis and Guy Pierno
Photographs pages 82–83, 116, 136, 138–139, and 164–165
 Copyright © 1982 Ann Brandeis
All other photographs copyright © 1982 Bob Casagrande

Project Editor: Sheila Rosenzweig
Production Editor: Gene Santoro
Design Assistant: Lonnie Heller
Produced and prepared by **Quarto Marketing Ltd.**
32 Kingly Court, London W1, England
Typeset by BPE Graphics, Inc.
Printed in Hong Kong

This Spectrum Book is available to businesses and organizations
at a special discount when ordered in large quantities.
For information, contact **Prentice-Hall, Inc.,**
General Book Marketing, Special Sales Division,
Englewood Cliffs, N.J. 07632
A Spectrum Book
10 9 8 7 6 5 4 3 2 1

ISBN 0-13-071332-5
ISBN 0-13-071324-4 {PBK.}

Library of Congress Cataloging in Publication Data
Casagrande, Bob.
 Better black and white darkroom techniques.
 (The Master class photography series)
 Bibliography: p.
 Includes index.
 1. Photography—Processing. I. Title.
II. Series.
TR287.C39 1982 770'.28'3 82-10118
 AACR2

Contents

This book is dedicated to Giuseppe Pino,
who is responsible for my awareness and appreciation
of the power of black-and-white photography.
May it outlive us all.

Acknowledgments

I would like to acknowledge the help, support and patience of the following people who have made my first book an enjoyable and unforgettable learning experience. **Giuseppe Pino,** for hours of dialogue on the art of black-and-white photography over the last six years. **Michael Robert Soluri and family,** for their support and guidance. **Ann Brandeis** and **Guy Pierno,** for the use of their darkroom facilities and their help in compiling miles of useful information. **Fran Black,** who is responsible for my introduction to Quarto Marketing Ltd., and **John Smallwood** and **Michael Friedman** of Quarto. **Sheila Rosenzweig,** my editor, who found time and patience to show me how a book is done, **Joseph Heppt, Michael Wade Blatt** and **Ivan Della Tanna,** for their contributions to the production of **Better Black-and-White Darkroom Techniques.** Most of all, I would like to thank **Barbara Winkler** for her constant support and understanding of the problems involved in writing my first book. Thank you all.

Introduction

In this book I have tried to put together the sort of information that an advanced amateur needs to really sharpen his potential skills. The terminology and concepts, however, are not out of the reach of anyone with a basic knowledge of black-and-white photography in the darkroom. But, due to the depth of the topic and the method used to relay the information, certain assumptions had to be made. To have explained every photographic concept in this book would have made it an encyclopedia instead of a compact book of practical darkroom information. Most terms and concepts that have special importance have been defined and discussed in great depth.

A point that I feel is important to emphasize is that a special darkroom effect is not an excuse to abandon the guidelines of design and composition and tonal quality. In fact, an entire chapter is devoted to design and composition and making a high-quality black-and-white print. The use of special effects does not improve a poor photograph. The photograph must be able to stand on its own. Not all prints can be manipulated and used in all special effects. How you determine which print works with each effect, and the extent to which you manipulate that print, are points that define your personal style and set you apart from the other photographers in your field. Don't be afraid to try different, unusual combinations of these effects, as well as to expand the procedures I have outlined. There is often more than one way to achieve the same effect, and not all of them are proper for your way of thinking. What I hope to achieve with this book is to provoke thought and to stimulate your interest enough to get you to try something new and different in the darkroom.

I hope you have as much fun in the darkroom with this book as I have had in researching and writing it. The flexibility and impact of black-and-white photography is only now being understood and applied; clearly, there is much more to it in the special-effects area than just solarizing prints.

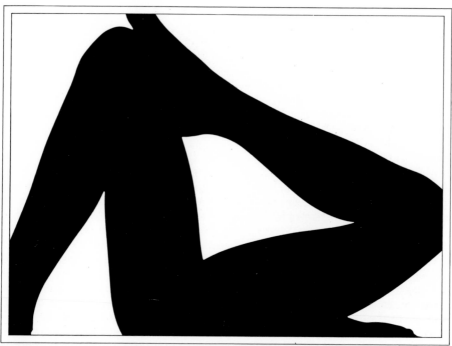

The crossed legs of this photo are a very graphic example of shape as a design element. To maintain balance and proportion, it is important to be aware of the space or shape formed *around* the subject. There should be a relationship between the negative space and the positive space of the image to produce a good composition. *Photo by Michael Wade Blatt.*

1

Visual Elements

Photography requires an exploration and selection process to take place either before the picture is taken or later, in the darkroom. Because it is easy to shoot many frames of the same subject, on one roll of film, many photographers never fully develop their skills. They are easily misled into thinking that quantity ensures success. Only if the photographer closely questions his feelings and then considers the various ways in which visual elements can be put together to express that meaning efficiently does he approach the process of exploration and selection, and thus improve his skills.

The above process leads to further questions concerning the analysis of picture taking. The photographer's feelings and thoughts on the subject depend on his past experiences with it. Emotions and memories create in the photographer a response that will affect his interpretation of the subject's meaning This happens unconsciously to an unskilled photographer. But to advance your skills and understanding of the art of photography, it is necessary to become conscious of the relationship between photographer and subject.

The first step is to become familiar and deal consciously with certain basic visual elements as they relate to photography. In the pages of this chapter are written and pictorial explanations of these elements; they are meant to put you on the road to becoming a more skillful and alert photographer. An important step in this process, though, is learning that rules, once

they are understood, are meant to be broken. The uses and implications of these elements are meant not to bind you to any structured style but to give you a basis for self-interpretation.

The five basic visual elements—shape, pattern, texture, form, and color—are not the only design tools the photographer can select. But once you can control these elements, you can combine them to create more complicated designs while maintaining a purpose. What you must remember is that good design is the organized presentation, complete and clear, of design elements used to express a point of view. How you structure the elements determines how you identify your own personal style of photography.

When combining elements, you will not only enhance your photographs but also increase the difficulty of your job as photographer. Try to use only the minimum needed to make a clear statement.

Up to a certain point, deciding what to include is determined by what already exists within the subject. The choice of equipment further affects the decision, as does changing your physical position in relation to the subject.

Light, tonal range, and color also influence design decisions. They are elements that some include in the definition of photographic design. From another point of view, however, light and tonal range can be seen as factors that influence and often determine a design element's identity. They can be considered as part of each element, not only as individuals.

11

COLOR

Color creates the strongest emotional response in the viewer and is an important element of photographic design. Although this book is about black-and-white photography, no discussion of the visual elements would be complete without the mention of color. Black-and-white films cannot incorporate the element of color, but it does have a major effect on how these films record tones.

In color photography, hues, tints, and shades separate planes and give the illusion of depth. A fully saturated color can be changed with the addition of varying degrees of white, gray, and black pigments to change the intensity of the color. If more black is added, the color undergoes a change of shades, depending on the amount added. If white is added instead, the color goes through a range of tints. Shades and tints are thus the tones of a color, while hue is the pure, fully saturated color, to which no white, gray, or black has been added.

When the elements of color and tone are combined to produce a shape, they give the subject substance and a dimensional form. Color has the ability either to please or to repel, based on the viewer's experiences and associations. It can also tell more about the area that surrounds the subject, as well as create mood and atmosphere. A dominant color can be broken down into various tones and hues to give the illusion of depth. By choosing tones of the same color, you create harmony within the photograph.

Tone is an important aspect of black-and-white photography. The relationship of the subject's grays, ranging from white to black, are referred to as a black-and-white print's tonal range. The tonal range will define the elements of form, texture, and pattern and is controlled by the way in which light strikes the subject. A black-and-white photographer uses tone to create atmosphere.

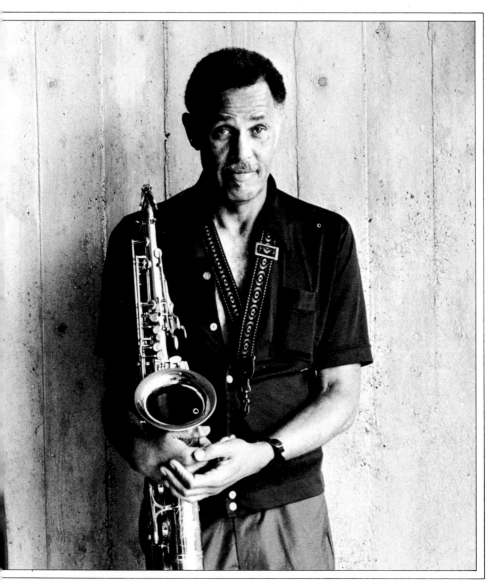

Shape can be used in conjunction with the other elements of an image to maintain a balanced composition. This photograph of musician Dexter Gordon is an excellent example. The large, graphic shape on the left is needed to balance the image of Mr. Gordon on the right. The good tonal range of this print helps to separate the planes. *Photo by Giuseppe Pino.*

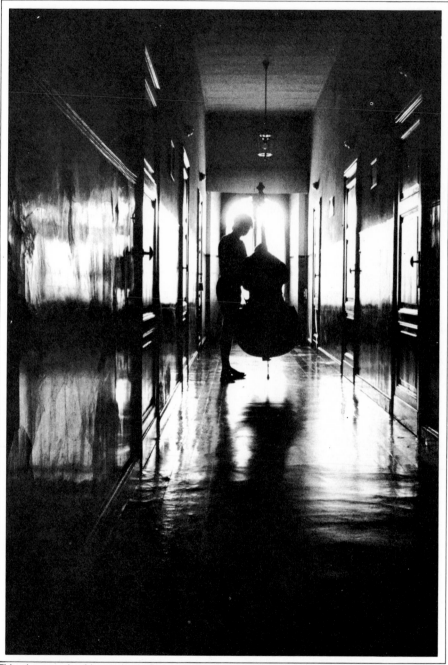

This photograph of bass player Cameron Brown is an example of how shape can be incorporated into a photograph without becoming an abstract form. The silhouetted image enhances the impact of the shot, creating a feeling of power. Note the good tonal range. *Photo by Giuseppe Pino.*

SHAPE

Shape is the two-dimensional outline of the subject, suggesting only its vertical and horizontal dimensions. Because it is a two-dimensional element, shape is easy to understand visually. More than any other element, it is the one that helps the viewer to identify the subject. Even after feeling the subject or smelling it, we still need to see its shape to confirm and verify our impressions.

If the shape of an object is shown in a manner that is normally not seen, the viewer's attention is drawn to that specific area of the print. Curiosity is created, and the viewer's eye is caught. Remember that shape alone gives no details or definition to indicate the actual identity of the subject. Used properly, shape alone is an effective design element, one that intrigues the viewer. But if shape is the only design element, sometimes the image may be too ambiguous, puzzling, or even annoying to the viewer.

Back-lighting the subject will produce a silhouetted image, a very powerful form because of the limited amount of detail. Paradoxically, this powerful form can also emphasize delicacy. Much information can be obtained from a silhouette even though there is a lack of detail. When properly done, a profile of a silhouetted person can be very strong, telling a great deal about character.

Side-lighting is an effective way to emphasize shape in the composition. Harsh side light will create strong, dramatic shadows; make sure that the shadows are not dramatic to the point of confusing the viewer's eye. Softer side light will create gentler shadows that seem to outline the subject.

Remember that when dealing with a shape graphically in a high-contrast situation, two shapes are being created—the negative space and the positive space surrounding it. They should be treated with equal importance.

Depending on which angle you photograph from and which lens you use, a number of different effects can produce different shapes for the same subject. A wide-angle lens can turn two parallel lines into a bowed-out shape if photographed from the proper angle. A long lens can produce a shape more in tune with the viewer's expectations of the image but still compress and change its shape.

Because shape is simple and two-dimensional, it can be used very graphically or geometrically to create another element of design—the repetition of a shape to produce a motif, or pattern.

PATTERN

Pattern is created by the repetition of lines or shapes. Unlike texture, it generally does not imply a third dimension, but it is a very graphic way of increasing pictorial impact and a powerful means of simplifying and enhancing an image.

Because of its potential for organizing a picture or directing the viewer's interest, pattern must be used carefully. If it becomes too repetitive, it will become static and lose control of the viewer's imagination. Changing your lens or altering your camera angle are two ways of introducing some variation into a pattern.

By separating pattern and working with it alone, you will start to see its potential and strength. In photography, this is initially a conscious process. Normally, when we see the pattern that bricks form in a wall, the focusing function of the human eye edits out the extra bricks and concentrates on the minimum number required to form the pattern. In photography, you must choose the lens and angle to edit down a scene and the lighting that will bring out the pattern in the subject.

When trying to give the illusion of depth by repeating a shape, keep in mind that depth is often destroyed when utilizing the element of pattern. Pattern, in its most basic form, is thought of as being

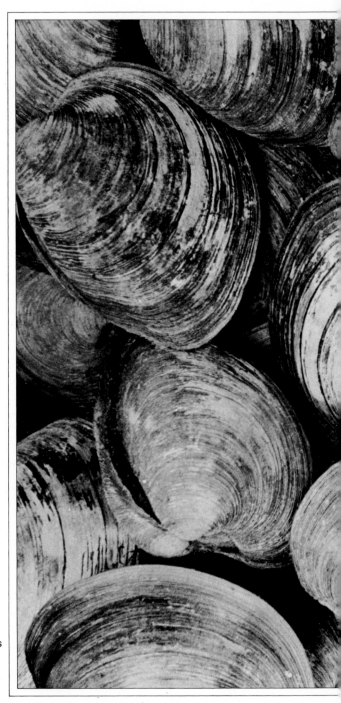

These clams are an example of natural pattern, not as organized or structured as man-made pattern. In this case there are two parts to the pattern effect, that pattern created by the heap of clams and another pattern created by the lines on each individual clam. This print was cropped to isolate the elements and increase viewing interest.
Photo by Joseph Heppt.

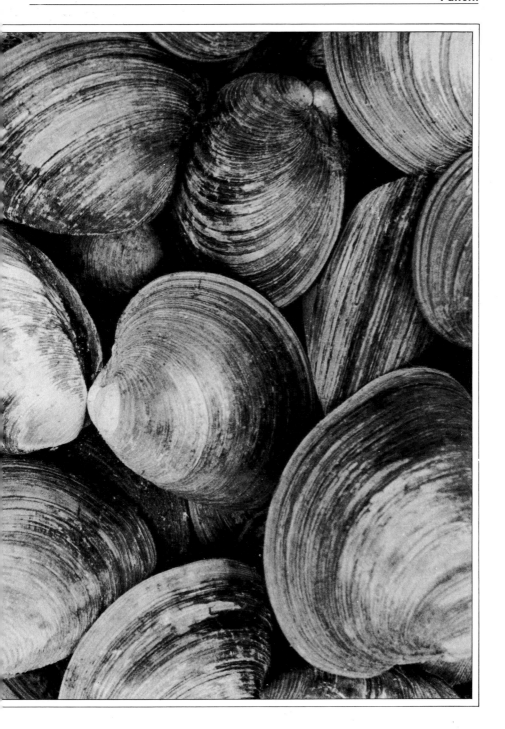

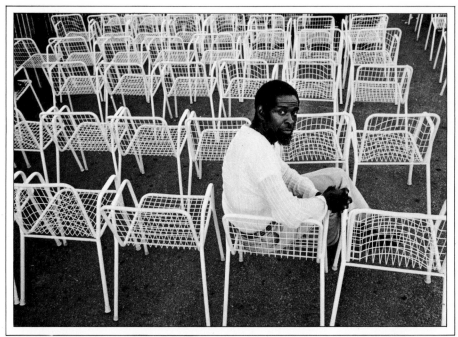

The receding pattern of the chairs, and the pattern of each chair itself, form a three-dimensional background for jazz musician Muhal Richard Abrams. *Photo by Giuseppe Pino.*

two-dimensional. Very flat, even light that does not give obvious, heavy shadows helps to maintain a two-dimensional quality. If, on the other hand, heavy shadows are created under contrasty lighting, there will be a third dimension in the pattern. This is still an example of pattern but in a more complex composition of elements.

TEXTURE

Texture is the characteristic tactile and visual quality of a surface. It is a design element that is often neglected, although it is closely related to shape and pattern and adds dimension to the photograph.

In photography, the depth and form of texture can be implied in a number of ways. One way is to use side light, which will cast a shadow from any raised surface of the subject. The contrasts between the points high enough to catch the light

directly and the areas that fall into shadow produce the effect of texture due to the tonal ranges that are created. A strong side light will emphasize textures of a very harsh character, such as rough surfaces. Softer examples of texture are created with a more diffuse light. Match the lighting to the mood you wish to create.

Lens and film combinations can also enhance texture. Moving in very close to the subject with a close-up lens helps to isolate and emphasize the third dimension of texture. Fine-grain films record the fine details and contrasts that are also part of texture. Every surface has texture. If you, as a photographer, are aware of its presence, you have increased your range of creative opportunities.

To emphasize only shape or pattern, it is often better to eliminate texture. This can be done with flat, straight-on lighting. When used as an element in the same composition with strong elements of

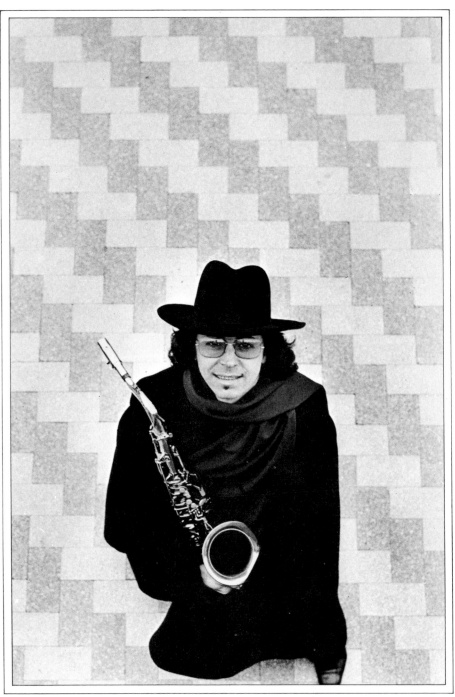

In this portrait of jazz saxophonist Gato Barbieri, the high camera angle incorporates the patterned pavement without overwhelming the subject. *Photo by Giuseppe Pino.*

The determining factor in representing texture is the lighting. In this example the light comes from the side and captures the sensation of a raised surface; without light that casts a shadow, pattern alone would be seen. The viewer can utilize his sense of touch while looking at the subject. *Photo by Michael Wade Blatt.*

shape and pattern, texture can become very confusing. Texture is often created most effectively by getting very close to the subject; pattern and shape, more often than not, require a more distant representation to be effective.

FORM

Shape is a two-dimensional quality that quickly defines a subject's space while lacking detail and depth. If shape is correctly lighted to give detail, texture, and depth, the illusion of three-dimensional form is created.

The lighting situation is very important here. Too harsh a light will dissolve the tonal gradations and create only a high-contrast shape of a two-dimensional quality. To add that third dimension, the shadows must have a bit of definition and the light must gradually wrap around the subject.

To create the visual illusion of three-dimensional form in a two-dimensional photograph, there are certain clues that a photographer must be able to control. First of all, form can be implied by the way in which shadows are cast, by the subject, and by the gradation of tones that results between the shadows and the highlights. Using a light that wraps around the subject either from above or from the side, in such a way that it gives depth to

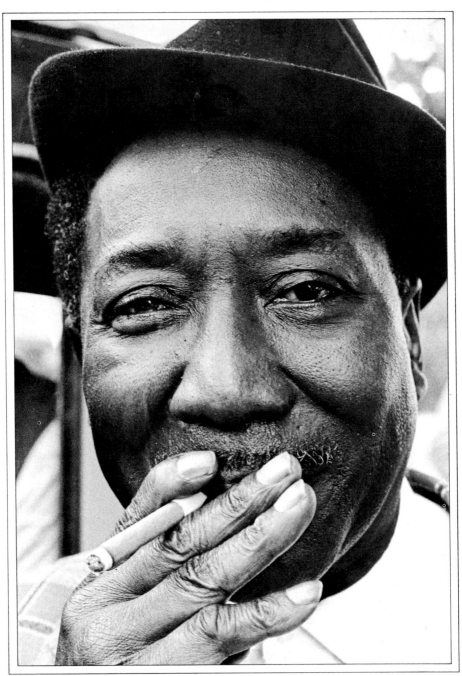

Blues musician Muddy Waters has a fascinating face no matter how he's photographed, but the addition of texture really tells the viewer much more about him. The soft side light wrapped around him in just the right way to bring out the texture of his skin, adding interest and impact to the shot. *Photo by Giuseppe Pino.*

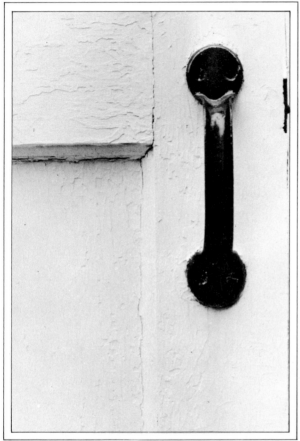

A well-composed photograph can be produced by isolating the element of form. In this graphic interpretation, contrasting tones are juxtaposed, indicating that the image is not flat or smooth even though there are no shadows. The dimensional effect is created by the gradation of tones, which separates the physical planes and tells the viewer that the black object is a handle. *Photo by Joseph Heppt.*

the image, gives a clue that there is a third dimension.

But lighting alone is not enough. You must also choose a perspective from which to shoot, one that takes into account the direction of the shadows and the highlight areas of the subject. It is up to the photographer also to decide how much of each area is required to clue the viewer. If there is more than one object in the photograph, closer ones overlapping farther ones, they can add to a sense of depth. Again, this is dependent upon the shadows and the perspective shown.

Form can only suggest the subject; no matter how realistic the photo, it is still only a two-dimensional representation of a real, three-dimensional subject. The viewer's imagination, as well as memory and past experience, is required to help complete the three-dimensional illusion. A photograph can be taken from only one side at a time; the viewer's imagination and past experience must fill in the de-

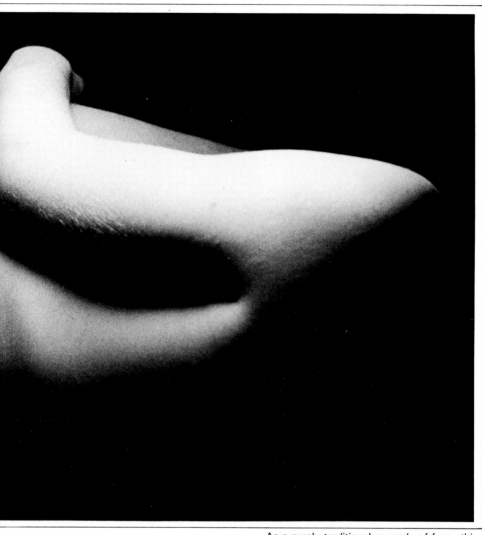

tails. The viewer makes certain assumptions, expecting that an object familiar to all, an egg, for example, can differ in a photograph only slightly from what he remembers an egg should look like.

Form calls attention to the particular part of the photograph in which it is located and is an excellent way to control the emphasis of the shot. As a very strong element, it tends to dominate other aspects of the composition; other elements must be incorporated very carefully.

As a purely traditional example of form, this photograph is excellent. The light wraps around the subject, producing the tonal gradation necessary to define the form and add a third dimension of depth not present in shape alone.

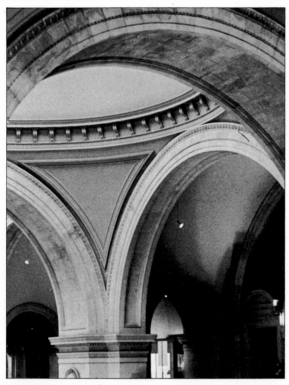

But for the gradation of tones, the viewer would not be able to tell which arch is in front of the other. The large arches produce one form and their ornamentation, which also produces a pattern, show us another. These properties indicate the depth of the arches and their relationship to each other, emphasized by printing on high-contrast paper. *Photo by Joseph Heppt.*

As an abstract form, this print has an eerie resemblance to the human heart. If not for the highlights on the right side of the heart, there would be no representation of form. These gradations give the form a rounded appearance and dimension. *Photo by Ann Brandeis and Guy Pierno.*

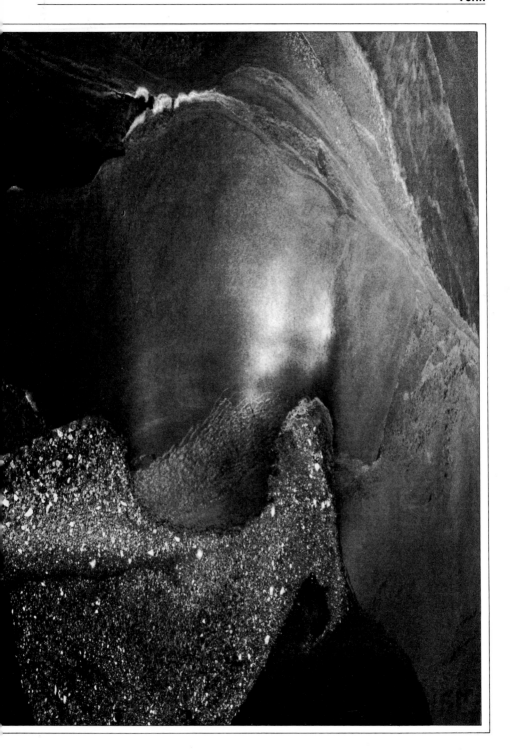

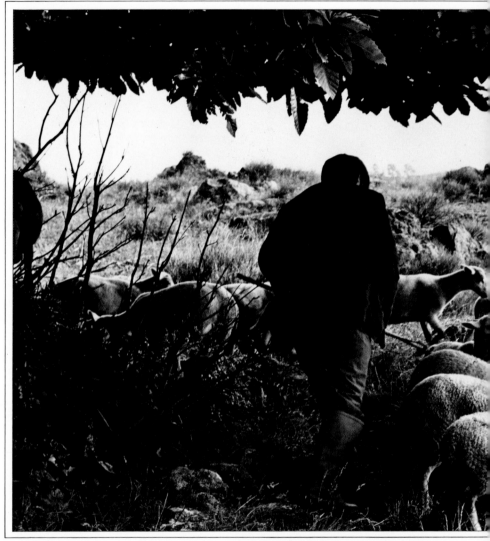

Careful framing made the shepherd the dominant element here. Less attention to framing might have made this shot more of a landscape than a portrait.

COMPOSITION

Pictorial composition can be thought of as the deliberate organization, arrangement, and juxtaposition of separate elements, establishing an arrangement between them to create a unified effect. The most important determining factor in composition is the manner in which each individual photographer takes the guidelines and modifies them by personal choice. Simply put, composition is a way of seeing, of visualizing an image in the mind's eye.

The basic elements of composition begin with the basic elements of design. In composition, the photographer follows a sense of personal order, editing and selecting according to his practical needs and aesthetic sense to determine a photograph's content. Composition evolves from content—the shape, texture, form, and other elements that dictate the design. Content can be defined as the visual, design, and nontangible themes of the photograph working together to make a statement. Composition essentially is the organization of visual elements and graphic design.

The arrangement of design elements in a composition varies depending on the photographer's perspective and the light. Within the practical limits of the situation, balance and harmony are created by considering the dominant and subordinate elements. The main subject of the photograph, the dominant element, must be in a pleasing relationship to the subordinate subjects, surrounded by those of lesser importance. More than one subject of equal strength will often produce visual confusion.

The dominant and subordinate elements can also control how the eye is led through the photograph. The viewer's eye should flow from the main subject around to the less important subjects and then back to the main subject. This gives the viewer a rhythm to follow, making the image more enjoyable to look at.

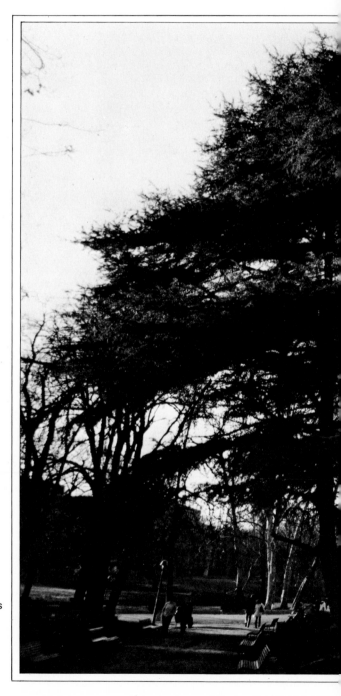

The darkness of the tree draws the viewer's attention; everything else in the picture is less important and smaller. A 20mm wide-angle lens was used to help create the unifying effect by rounding out all the straight lines. This improved the covering effect of the tree and gave it more power and importance.

In composition, the framing of the subject also affects the balance and harmony of the photograph. When framing, two points must be considered. The first is to look at the elements of design in the composition and to think about how they will be affected by the framing; the second, how the elements will relate to one another within the frame.

Individual style is a result of composition with a personal approach to the subject matter. Combining all of the elements of composition does not necessarily mean a photograph will be successful, but it is true that many successful photographs do incorporate more than one element of composition. It is important to learn just how much of each element is necessary to work well with the other elements being incorporated into the composition. The photographer's choice of what to include is an indication of his personal style.

DOMINANT AND SUBORDINATE ELEMENTS

It is often best to analyze composition one step at a time. An appropriate place to start is the relationship between dominant and subordinate images in a photograph. If understood and controlled properly, this relationship can greatly improve the sense of unity within the photograph.

A dominant element is any object in the picture that attracts immediate attention. The dominant element is often the main subject of the photograph. Care must be taken to prevent the surrounding objects from becoming overbearing, since this causes confusion and frustration for the viewer. In an effective photograph, the viewer always knows immediately which point to focus on first.

Generally, a large shape that is very light or very dark will have more impact than a smaller shape that is a mid-gray color. On the other hand, a small, bright shape may have more impact than a large, mid-range one. The visual weight of a

subject can be related to the rest of the design elements to achieve balance, rhythm, perspective, and proportion. If the subject is visually subordinate, ways must be found to make it the central element of the photograph.

One way to create dominance is by the use of converging lines in the composition to lead the viewer's eye to the subject. Finding converging lines is often as easy as simply changing your point of view to include already-present lines in the composition. Changing the camera perspective, by looking down or up at the subject or by choosing an unusual angle, can add emphasis to line. Changing the lens perspective, by using a wide-angle lens, for example, is another way to draw the eye to the subject. The lines leading to the dominant subject need not be straight; in fact, curving lines are often the most effective.

It is possible to carry the idea of converging lines too far and end up with shots that are either boringly similar or that use odd angles to cover up a lack of basic interest in the subject. Think carefully about the shot and experiment with several different approaches.

A frequently used but very effective method of drawing attention to the subject is to frame it within a foreground or background shape. Windows and doorways are commonly found frames, but with a little imagination you will see natural frames all around you. When framing against a light background, a dark subject against the light is a good technique. Conversely, light subjects against dark backgrounds often make for striking shots.

BALANCE

In the purest sense, formal balance is an image of two identically sized shapes, equally represented within the frame. *Equal* in this case means that the relative visual weight assigned due to color, tone,

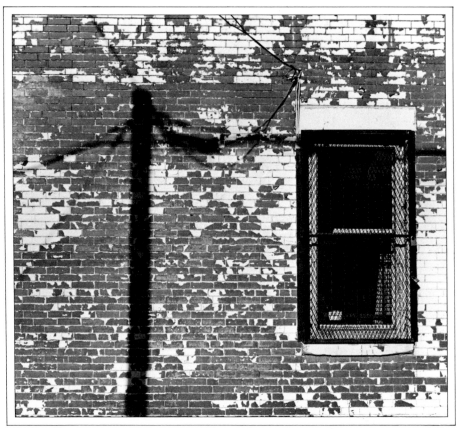

This well-balanced, traditional photograph would be poorly framed but for the shadow of the telephone pole. The elements of pattern alone would not have been enough to carry the composition succesfully. *Photo by Joseph Heppt.*

location in the frame, and the degree of interest evoked is the same for each object. According to this definition, a sense of stability and comfort is created by maintaining an equal balance of all the elements. But to increase the photograph's ability to attract attention, it is sometimes preferable to create tension among the elements.

Unbalance is just that: favoring the visual weight of one of the elements more than that of the others. The degree of relative visual weight assigned to a particular shape can control varying amounts of the viewer's interest. For an example, consider a potential scene containing three elements: a telephone pole, a man, and a telephone booth. Each of these elements could be clearly and cleanly

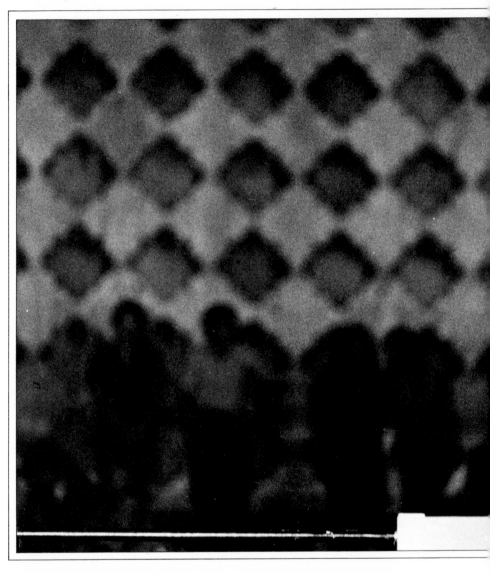

placed in each third of the frame. This would leave enough room around the subjects to avoid confusion or tension, but the problem is that the image could have been made by anyone. To show your own view of the subject, you must think about an uncommon approach to it. Experiment for yourself. If the shot doesn't work visually, study it and understand why not. Try shifting the balance of your composition drastically to one side. View the scene from every angle and find a way to say who you are by using photographic composition.

Individualism in photography is easily seen in the accompanying photographs. Each is an example of a particular photographer's view of the subject. Each has its own identity created by manipulating the element of balance.

The power of symmetrical balance in composition is captured in this shot. For every object on one side of the print there is another object on the other side to maintain the equal balance. Although the objects are not necessarily identical, they control the same amount of visual attention.

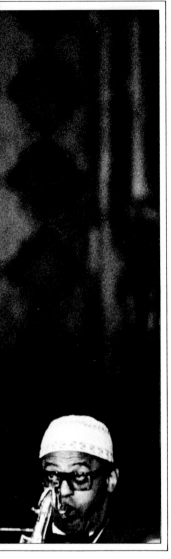

Large amounts of gray tones were needed to create a balance for the whites in the lower corner of this shot of musician Archie Shepp. The use of pattern helps occupy the eye in that section of the print, increasing the visual balance. *Photo by Giuseppe Pino.*

Deliberate unbalance is useful in this photo (overleaf) to enhance the feeling of the woman walking. The viewer knows that she is headed out of the frame. The pattern on the right-hand side of the print contains the eye and keeps that part from becoming static open space.

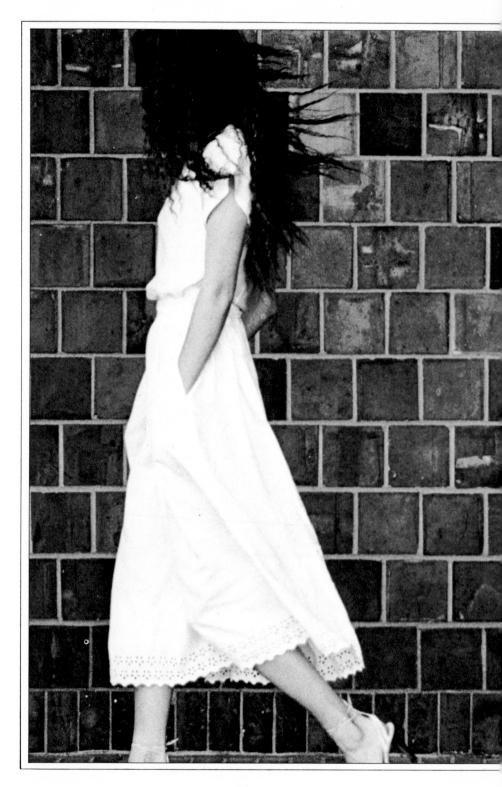

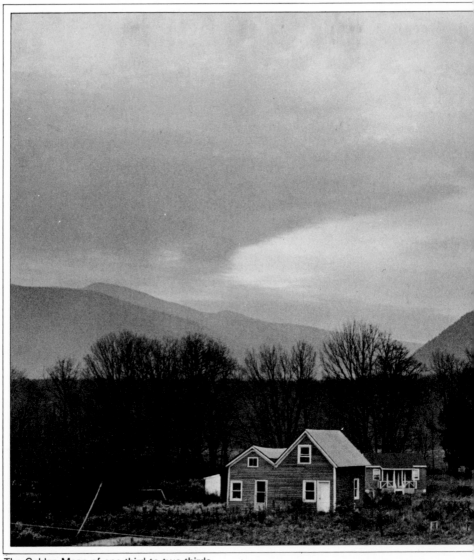

The Golden Mean of one-third to two-thirds is effective in keeping this photograph from becoming boring or static. It captures the sense of vastness that existed in the original landscape. The tonal range becomes less contrasty and more gray due to aerial haze as the objects recede from the camera. *Photo by Joseph Heppt.*

PROPORTION

The traditional proportions for pictorial composition are one-third to two-thirds, sometimes known as the Golden Mean. Formulated by the ancient Greeks, the Golden Mean still has validity for modern photography. In landscape photography, for example, the most pleasing photos frequently fill one-third of the frame with

asymmetry are valuable compositional tools. A large amount of sky in a landscape, for example, creates a feeling of vastness; in a formal treatment of a subject exact centering is sometimes appropriate. Often, however, the most pleasing and balanced composition falls into a natural one-third/two-thirds ratio.

To apply the principle of the Golden Mean, imagine the scene divided into both horizontal and vertical thirds. Try to place important design elements at the intersections of the imaginary grid or along one of the imaginary lines. Remember, of course, that the thirds do not have to be exact and that you are free to place design elements wherever they will have the most impact.

In organizing the design of a photograph, you can choose a lens, such as a wide-angle, and move in close to the subject to create distortion. The use of a telephoto lens will compress the perspective and create a different sort of distortion. For example, a telephoto will increase the crowdedness of people on a city street during rush hour.

The angle you choose to shoot from will also control the perspective. If you stand at the base of a skyscraper and point the camera up a side of the building, the lines of the building will appear to converge to a point, like those of a pyramid. If you shoot down on a group of people from a window of that building, you will create the impression that the people are very short and flat.

By choosing a background with different-size objects, one in front of the other, you can create the illusion of depth. Or you could place the subject against a neutral background, such as a building against a clear blue sky or a friend in front of a gray cement wall, to isolate the subject from a busy background.

The aperture of the lens will control the depth of field. With the aperture wide open and depth of field shallow, you could focus on one person in a crowd and

sky and the remainder with the scene, or vice versa. Dividing the scene evenly, with the horizon line running across the middle of the frame, is symmetrical and usually dull. Showing large amounts of sky and little land may seem unbalanced and unnatural.

The Golden Mean is a guideline that can be creatively broken, however. There are times when symmetry or extreme

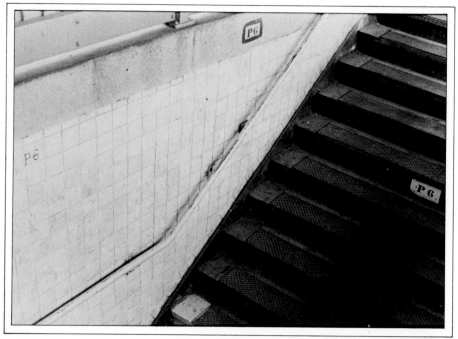

In this example proportion almost splits the print into equal parts; the visual weight that each half of this New York City subway entrance commands is equal. This could cause confusion for the viewer, but the added elements of pattern and form create continuity. *Photo by Joseph Heppt.*

separate that person from everyone in front and behind. This would give the viewer immediate knowledge of the subject. A small aperture setting in the same situation would give greater depth of field and create the illusion of a sea of people.

Manipulating the shutter speed can also influence the design of the photograph. A slow speed at a car race, for example, could help enhance the feeling and power of the speed of the cars by creating a blur across the film. If, on the other hand, you panned with the subject or used a faster shutter speed, the motion of the race cars would be frozen at the moment the shutter was tripped, giving them an eternal place in time.

The exposure given the film determines how the shadows will reproduce on the print. Big shadows with no details appear moody and mysterious; open shadows are revealing and informative. The amount of time the film is developed will also influence the shadows and is, therefore, another design decision.

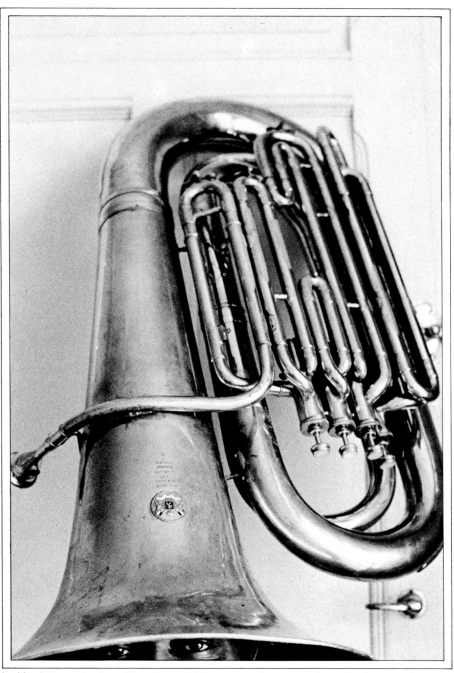

In this photograph of musician Howard Johnson, another approach to the element of proportion is illustrated. The contrast between the tones of the tuba and Mr. Johnson's face creates a proportion that maintains balance. The size relationship produces an enjoyable composition. *Photo by Giuseppe Pino.*

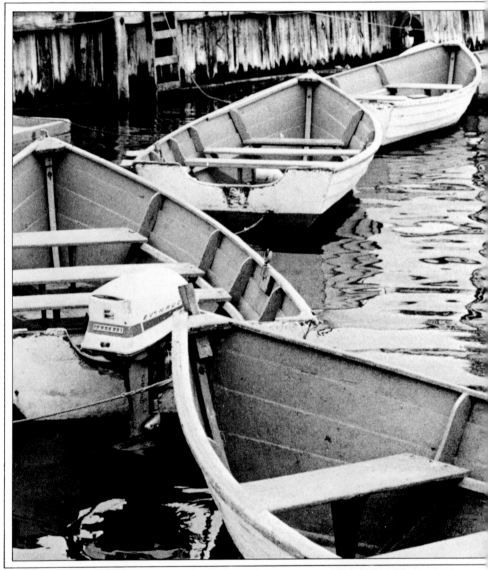

Pattern and rhythm often go hand in hand. In this shot the shapes of the boats are not entirely shown, but they create a pattern that the mind's eye can finish. The eye starts at the boat in the foreground of the print and then follows the sequence around, boat by boat.

RHYTHM

Rhythm is created whenever similar pictorial components are repeated at regular or nearly regular intervals. This repetition, or pattern, carries the viewer's eye through the photograph, controlling the amount of time spent looking at, and therefore the amount of attention paid to, any one element. Rhythm is a way of producing order and unity in the photograph.

Rhythm is also a psychological effect that directs how the eye flows across the elements in an image. The word comes from the Greek word *rhein,* which means "to flow with a recognizable pattern." This flowing pattern occurs over a period of time, the time it takes for a viewer's eyes to travel from one point to another in the photograph. When similarly shaped objects are placed together, the amount of time the eye spends going from one object to another is decreased, because the distance between the objects is shortened. The viewer then understands and enjoys the picture more quickly and easily.

Rhythm is important to composition because it affects design decisions. In an asymmetrical composition, for example, the distance between the design elements is unequal. The viewer must therefore move his eyes an irregular distance each time he takes in a different part of the total composition. If his eyes must jump too much or too suddenly, the rhythm of his viewing is disrupted and he will have difficulty comprehending the photograph. Even worse, he may lose interest in it.

However, rhythm is not the same as symmetry. The intervals between design elements need not be exactly the same to create a pleasing sense of rhythm. Rhythm is a subtle effect, and subtle differences in placement are often sufficient.

PERSPECTIVE

By combining lines that converge to a point on the horizon and objects that

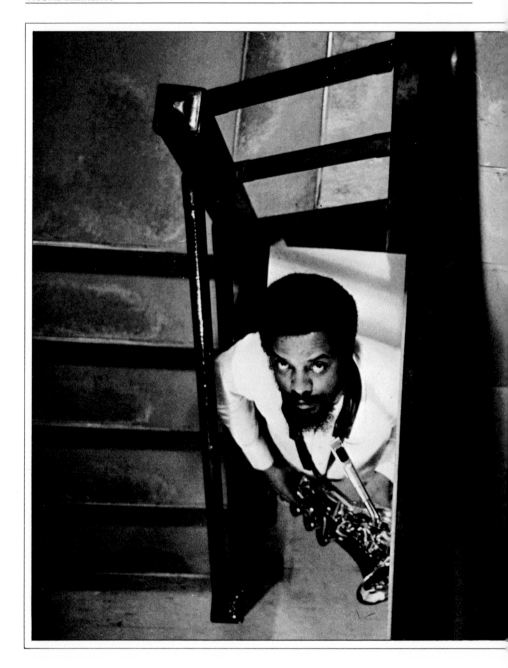

Rhythm is incorporated in an unusual way in this shot of jazz musician Hamiet Bluiett. The viewer's eyes "walk" down the steps and are led to the subject, a simple but rarely used concept.
Photo by Giuseppe Pino.

As an abstract example of rhythm, this stone wall is a very good way to explore this compositional element. Rhythm is established by the texture, tonal gradation, and pattern. *Photo by Joseph Heppt.*

shrink into the distance, the illusion of a third dimension—perspective—can be created within the limited confines of a photograph.

There are two types of perspective in photography. The first is linear perspective: the way in which, with distance from the camera, lines converge to a vanishing point on the horizon and objects diminish in size. The second is aerial perspective, the volume of space between the viewer and the far horizon. The illusion of depth is created with aerial perspective because tones lose detail and intensity due to aerial haze as they recede into the distance.

Both linear and aerial perspective are determined by the photographer's position and the lens he chooses to use. Tele-

photo lenses tend to compress depth, while wide-angle lenses tend to expand it. This means that aerial perspective can be enhanced simply by changing lenses.

Emphasizing the linear perspective of a symmetrical composition can help keep the composition from being dull. By altering your viewpoint, you can emphasize or exaggerate the converging lines of linear perspective; shooting from above or below the subject often has this effect.

Aerial perspective is a good way to create depth when the scene has little linear perspective. It is used to the point of cliché in landscapes, where receding hills, for example, are often used to suggest distance. However, aerial perspective is also an eye-catching creative tool in other sorts of composition.

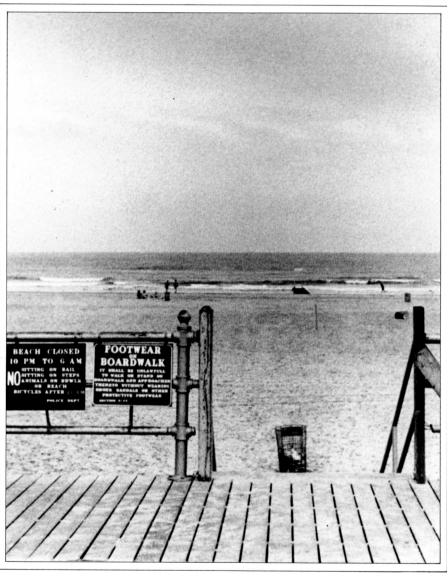

This picture clearly expresses how the focal length of the lens relates to the subject's size and distance from the foreground. The people on the beach in the background are small in comparison to the railing in the foreground; this size difference helps indicate distance and create perspective. The compression of depth is due in part to the telephoto lens and the angle from which the picture was made.

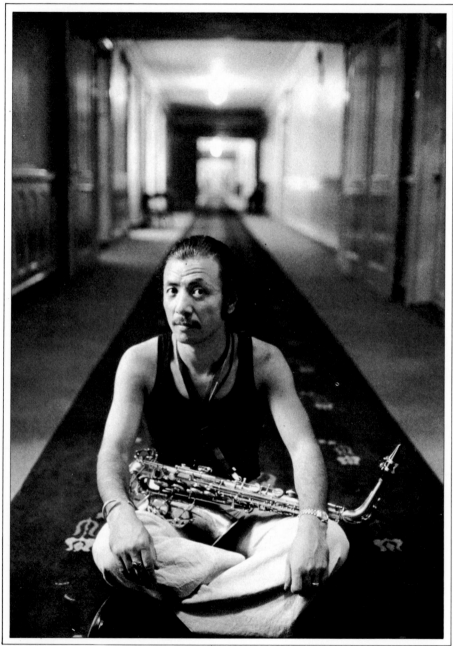

An effective use of linear perspective is shown in this photograph of Sadao Watanabe. The lines converge toward a vanishing point in the upper third of the image, behind Mr. Watanabe, and on the same line as his head. This aids the viewer's eye to travel to the proper area of focus, as well as indicating depth. The framing helps contain the eye at the front of the image; the tonal differences between the foreground and the background help separate the elements. *Photo by Giuseppe Pino.*

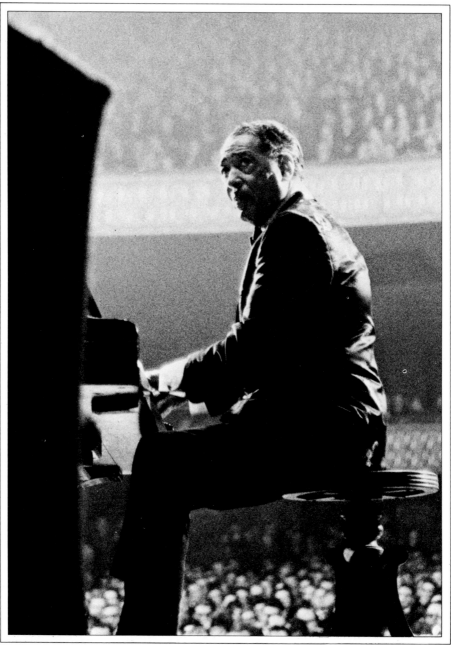

Aerial perspective is often illustrated by a landscape taken from a raised camera angle. However, this evocative shot of Duke Ellington was taken from a low camera angle using a medium telephoto lens. The effect of aerial perspective is created in part by the distance between the photographer and the audience and in part by the difference in the lighting between Mr. Ellington and the crowd. *Photo by Giuseppe Pino.*

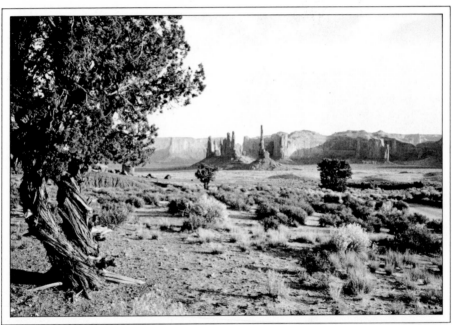

This is the first print in a series. The exposure was fine for the bushes and ground but there was no detail in the sky to express the dramatic scene that actually existed. It is often hard to determine the quality of tones in a landscape print because there is nothing to use as a determining tone. We can remember the actual scene to a certain extent, but we can also confuse the tones in memory.

2

Making a High-Quality Black-and-White Print

To make a high-quality black-and-white print, first we must become familiar with what black-and-white quality is and find a way to control the processing to obtain consistency. Every step of the process must be analyzed to help achieve a better understanding of what really happens. Once this is done, more time can be spent on the creative end of making photographs because the technical side of picture-taking becomes second nature. You will no longer spend a lot of time deciding which steps to take, and your photos will have more spontaneity.

For better black-and-white quality you must understand the relationship between the eye, the subject, the exposure meter, the film, the camera controls, the film developer, and the paper. Then you must find a picture-making method that takes into account all these factors and compensates for tonal and quality losses due to materials. A basic starting point is the modification of exposure and developing times to compensate for the subject's brightness. This is the basis of the Zone System, which will be discussed later.

The human eye can perceive a subject-brightness ratio of 1,000:1. This means that if the brightest area in the scene is 1,000 times brighter than the darkest, the eye can still take in the entire scene. Black-and-white film, however, when developed normally, can capture a subject-brightness ratio of only 256:1. Photographic paper has a subject-brightness ratio of only 100:1. Based on these facts, the goal is to maximize the subject-brightness ratio by manipulating the

shortcomings of the photo materials.

Despite these differences, a photograph may still seem to capture what your eyes saw because the tonal relationship of the final photograph is proportional to the actual scene. A subjective appraisal, along with an equally subjective memory of the various brightnesses of the subject, strongly remind you of what you saw when you made the photograph. But what about someone who wasn't there and has no memory of the original scene? For this reason we need an objective basis for judging the quality of a black-and-white print.

When looking at a high-quality black-and-white print, we want to see a smooth gradation to the highlight areas. This means that the diffuse highlights, those with some detail, have a tonal separation from the specular highlights, which will print paper-white. The middle gray tones must also have a definite separation between each tone; the shadow areas must be broken down into one black area with some detail and another area of total black. The darkest shadow area is the foundation upon which we will base all of our other tones. We need that area of true, saturated black to help define our tonal range.

The paper contrast grade used to make the print is very important in determining how much separation and how many different tones we will have. The higher the paper grade, the more condensed the tonal separation is; this means fewer tones. If too low a paper grade is used, the tones will all be flat; there will be no

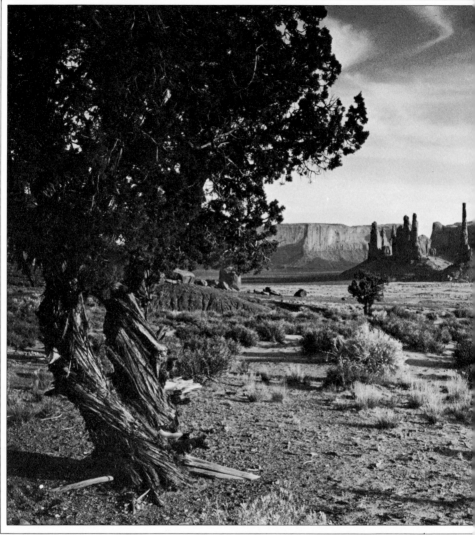

As much as the first print was correct for the ground and bushes, this one is good for a dramatic sky. The only problem is that the rest of the scene is too dark. It is up to the photographer to determine a point of attention, but avoid destroying the other tones involved.

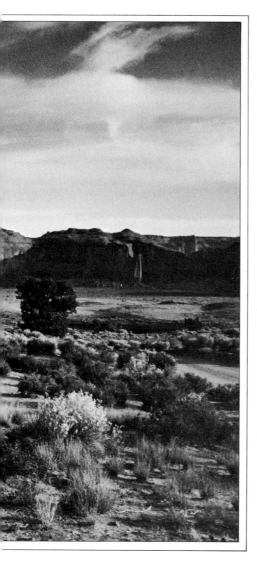

way to obtain a true black without the highlights becoming muddy gray. The contrast level must also be appropriate for the subject, as must the sharpness and the noticeable degree of graininess.

The print's quality, based on its tone separation, lack of graininess, adequate sharpness, and overall cleanliness, is dependent upon the controls used and any selections and adjustments made during the photographic process. These include the choice of lens, both for the camera and the enlarger, the film used, and the exposure given to that film. The film developing times are adjusted to give a negative that will produce a quality print with a particular enlarger. The paper selected must be appropriate for the purpose of the print and for the subject. When making a print for reproduction, you may want to make it lighter than you normally would, because it will pick up density when reprinted in the publication. The proper contrast level of paper must be in accordance with the negative's contrast and also with your particular enlarger. Any of the decisions you make concerning the above points will have a noticeable effect on the final outcome.

The apparent brightness of an object depends upon its surroundings; therefore, the eye makes a subjective measurement. However, if we think of brightness as being a measure of the amount of light that either falls on or is reflected by the subject, we can start to deal in objective measurements.

The light that falls on the object is called incident light. It can be measured by the use of an incident-light exposure meter, the kind used by professionals particularly when the subject is back-lit or when they are working in a studio with controlled lighting.

The light that reflects back from the object is called luminance, or reflected light, and can be measured by a reflective-light exposure meter. This is the type of meter found in built-in through-the-

lens meters and in most hand-held meters. A luminance meter is designed to indicate an exposure setting that will record 18 percent of the reflected light on the film. In other words, the meter will indicate the optimum exposure for recording the medium grays of the scene, if film and paper are processed in normal fashion.

When working with either type of meter, it is often better to bracket: make an exposure one stop over and one stop under the indicated reading to ensure a negative of the best exposure. This is more important for color films because you must consider the color value of the subject as well as its luminance. Black-and-white films have more latitude and more control in the darkroom than color films, but bracketing is still helpful.

A very accurate method of obtaining tone control is the Zone System. It was first developed and named the Zone System of Planned Photography by Ansel Adams, who was the first to systematize how experienced photographers manipulate their materials. In effect, the Zone System allows the photographer to decide, before making the picture, where certain tones (into which zones) of the subject are to be. Then, to determine the exposure, meter for an exposure that will give the darkest shadows of the subject detail on the negative. The negative is then developed (either over or under) so that the highlights will print according to the predetermined zone. If properly exposed and developed, a full-scale negative will print on a normal-contrast paper (grade 2 on most photo papers), with no need for dodging and burning, except for creative effects.

A full description of the Zone System can be found in Volume 2, *The Negative*, of Ansel Adams's "Basic Photo Series," or in *The New Zone System Manual*, by White, Zakia, and Lorenz, which is less mathematical.

Densitometry is an accurate way of determining the exact qualities of devel-

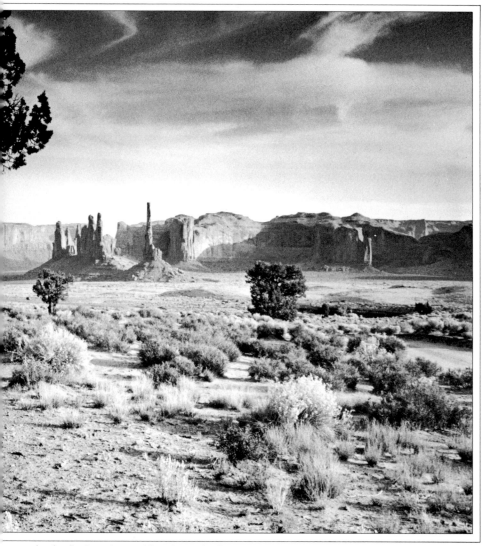

As the final product, with a dramatic sky and good tonal quality in the ground and bushes, this print has the emphasis in the sky. The tonal difference between the foreground and background gives a sense of depth to the image. The sky was burned in for 100% more time; the foreground was held back by 50%.

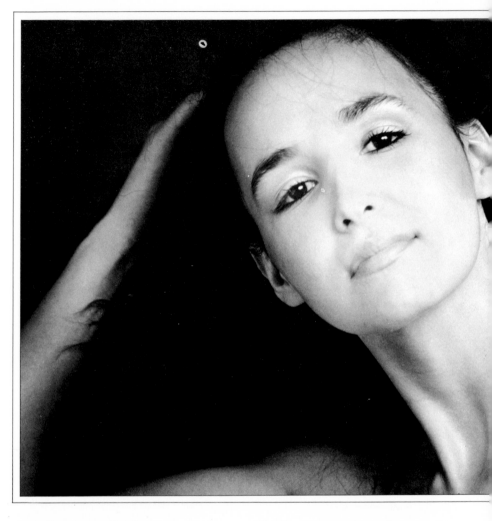

oped silver in a print. It is not synonymous with the Zone System but is a useful adjunct to it. The Zone System, when used properly, will produce a value for the lowest printable density on the negative, which is referred to as Zone I. Because this value is so close to being nothing more than a clear piece of film, to get an accurate measurement of the density in that area, an instrument called a densitometer must be used. Few photographers own densitometers, but almost all photo labs do. Most will take readings for you for a small fee.

The densitometer is used to measure the amount of developed silver in an area of a negative that has light-stopping ability. This is more simply known as the density of a negative. In any given part of a negative, the density is dependent upon the relative amounts of exposure and development that area has received. If we measure and assign a numerical value to these different areas of density, we will be able to plot a graph showing the relationship between the density and the degree of exposure given to arrive at each density. This is known as a characteristic

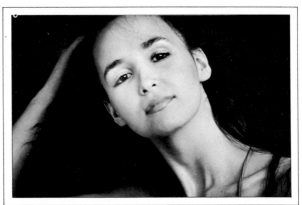

Skin tones are a bit more easy to determine, because we can look at our own and come up with a close representation. This does not necessarily mean it is easy to make the *real* tone. The print left is too light overall, particularly in the face. There is little detail in the side of the nose to give it form and help add the proper dimensions to the subject's features. After increasing the exposure time in printing the photograph above, I found the skin became too blotchy to look healthy. There is now good definition in the nose, but the hair disappears into the background.

curve. There are some other names for the characteristic curve, such as D log E curve, which stands for density-logarithm of exposure. Another name that is fairly common is H&D curve, which comes from Hurter and Driffield, the men who devised it.

The characteristic curve is actually a portrait of a developed piece of photographic film. The vertical axis of the graph is the degree of density; the horizontal axis is the amount of exposure required to get each density, given in the form of a logarithm.

Because there are 14 or more exposure gradations to plot on the same graph, logarithms are used to bring the proportions of the graph down to a more workable size.

The first part of the characteristic curve shows how much density is created by the emulsion/developer combination alone. This is known as fog. The closer the line begins to zero, the less fog there is.

The point on the curve at which the tones actually begin recording is known as the toe. At this point the emulsion speed can be determined by how close the

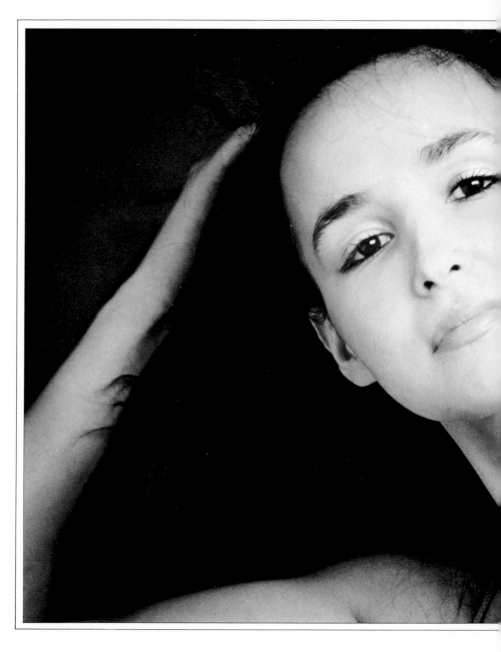

toe begins to the horizontal axis (log exposure axis). The closer it is, the faster the film.

Immediately after the toe is the straight-line portion, which shows the level of contrast that can be found in this emulsion. The steeper the line is, the more contrast exists. The longer the line stretches across the horizontal axis, the more latitude can be expected of this particular emulsion.

From the straight-line portion of our graph we can also tell whether there is good tonal separation by seeing if the density in the film increases in equal amounts for each log exposure increase.

Here is the final product of dodging the face for 20% and burning the background in by 10%. The tones on the face are correct to give the actual color difference between the eyebrows and the eyelashes. The lips are soft and light, as they actually appeared on the model, and the form of her face is properly defined.

(Measuring 0.3 units on either axis is the equivalent of one full stop.) Tone separation is never as good in the toe and shoulder region as in the straight-line region of the curve. If we overexpose too much, most of the densities will fall in the shoulder region. This would mean poor tonal separation in the highlight region. If

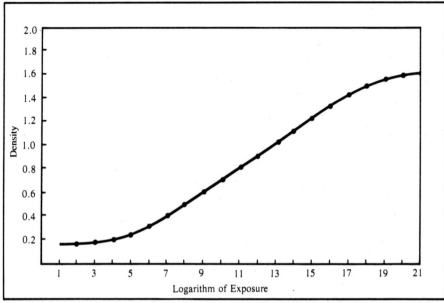

This chart shows the characteristic curve for a correctly exposed and processed negative.

we underexpose, the densities will fall in the toe region; this would mean poor tonal separation in the shadows. Ideally, we are aiming for a well-developed and well-exposed negative that is mostly located on the straight-line region, with its end just entering into the toe region.

The resulting placement of the negative is dependent, in part, on the amount of exposure and the tonal range of our subject. The method of ensuring proper placement is related to the film speed. When a film speed (ASA) is used correctly with a correctly operated meter and an average lighting ratio, the exposure will fall into the proper area of the curve.

There are a number of variables that will change the shape of the curve. Differences in developing time and dilution and/or the temperature of the developer are the two most important. By analyzing the characteristic curve of a processed piece of film, we are able to find what adjustments must be made to obtain the best-quality negative and which variables have had an effect on our film. If the

curve turns out to be perfect, we can use the processing data from that film to obtain consistency in other films with the same ASA or film speed.

More information on characteristic curves, including graphs, can be found in two special publications from Kodak, *Practical Densitometry E-59* and *Kodak Professional Black-and-White Films F-5*. For information on Kodak films and also those of other manufacturers, see the *Morgan & Morgan Darkroom Book*.

After obtaining a quality black-and-white negative, a quality black-and-white print is much easier to make. To find good examples of high-quality black-and-white prints, go to galleries, museums, or libraries. You can develop a feeling for black-and-white quality only by experiencing the photographs in person. Magazines, newspapers, and other periodicals do not usually have the highest-quality prints, because they are dealing with a reproduction, a second- and sometimes third-generation copy of the original. In addition, time and cost limitations have

an effect on the outcome. There are, however, certain publications that pride themselves on a very high print and reproduction quality. *Aperture, Zoom, Camera Arts*, and *British Journal of Photography* are excellent examples.

ARCHIVAL PROCESSING

Once you have obtained a high-quality negative, you will want the print from that negative to last indefinitely. A normally processed print will last approximately 20 years, with minimal fading, depending on the variables involved. This is because the silver halide crystals are susceptible to pollutants in the atmosphere. Special attention must be given to the processing, handling, and storage of a photograph if it is to be archival.

After the development and stop-bath stages of print processing, the most important aspect of archival prints is proper fixing.

A fixing solution is made up of hypo (sodium or ammonium thiosulfate), acid (sodium sulfite, which is a preservative), and potassium alum, a hardening agent. Each element serves a particular purpose. The hypo works to dissolve undeveloped silver crystals. The alum keeps the gelatin of the paper from swelling or contracting during washing, while the acid creates a favorable condition for thorough hardening. The preservative is necessary to keep the hypo from being decomposed by the acid. If insufficiently fixed, a print will not last as long as it should. If fixed too long, the fixer solution will cause the print to fade, much as a bleach would. An efficient method of ensuring complete fixing is the use of a two-bath fixer. Place fresh fixer in two trays side by side. For one-half of the full fixing time of five minutes, soak the print in the first tray. After two-and-a-half minutes are up, place the print in the second tray for the remaining time. Then wash in running water at 68°F for at least 20 minutes.

It is important to wash the print thoroughly after fixing so as to remove all traces of fixer from the paper's base. You can test the thoroughness of your wash by placing a drop of potassium permanganate in about 10 ounces of tap water. After vigorous shaking the water will turn a light-pink color. Place a small drop onto the white edge of a washed print; if the solution changes color, rewash the print for another 20 minutes and test again.

BLEACHING

Bleaching is used to lighten overly dark areas or to reduce the overall tonal quality of a print or negative. It is made by mixing potassium ferricyanide with regular fixer. It is the fixer that activates the potassium ferricyanide, which is a poison. BE SURE TO USE THIS CHEMICAL IN A WELL-VENTILATED AREA AND KEEP IT AWAY FROM YOUR EYES AND MOUTH.

Start the bleaching process by diluting the potassium ferricyanide with fixer. The more diluted you make the bleach, the more control you will have in restricting its effects to only those areas that need it. If the effect is going too fast, wash the bleached area with fresh, uncontaminated fixer. Use cotton swabs to apply the bleach to localized areas of your print. Be sure to clean off any excess moisture on the print.

For overall bleaching, start with the print in a fixer without hardener for three-quarters of the full fixing time. As soon as the desired amount of tone has been removed, return the print to the fresh fixer tray for the remaining time. Wash the print thoroughly and dry as usual.

Remember that the bleach is actually eating the layers of silver in the print and that the effect cannot be reversed. For this reason, always make more than one print. It may take more than one try to get the subtle effect desired. Bleaching is not a way to make up for bad printing; it is meant as a last resort.

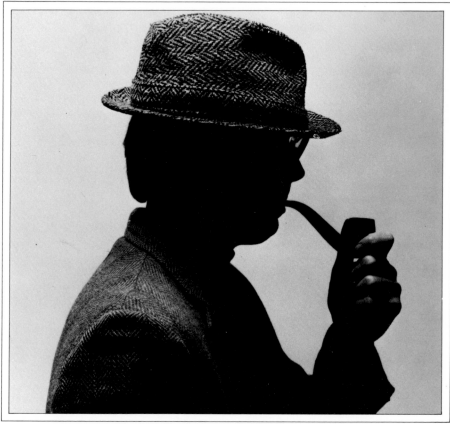

The background in this shot was lit too much for it to wash out and produce the desired result. There are two ways to correct for this: one is to reshoot. If time does not allow this, the other alternative is to bleach the print. *Photo by Michael Wade Blatt.*

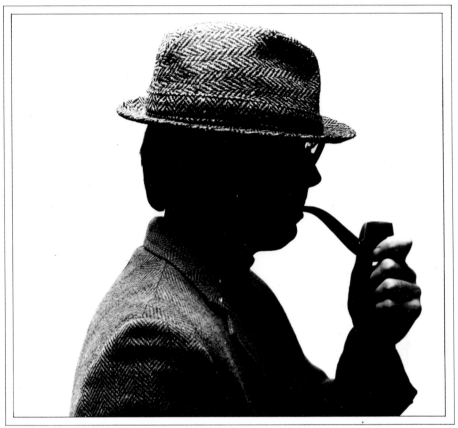

Potassium ferricyanide, when mixed with fixer at about 1:15, produces a light yellow bleach that will remove the silver from the exposed parts of the prints and make them white. You should bleach a print before you dry it; it is better to use a fixer without hardener. First fix the print for about three-quarters of the normal time and then place the bleach onto those areas that need it. Just before the desired amount of bleaching has taken place, return the print to the fixer for the remainder of the fixer time. *Photo by Michael Wade Blatt.*

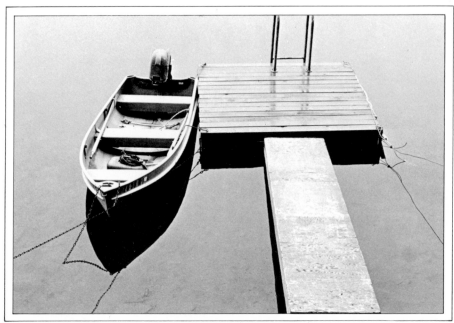

This print was made on Agfa Brovira paper and developed in Dektol developer. The contrast and tones are correct for the lighting situation, but the mood is too cold. Notice that the shadows have very little if any detail. The blacks also take on a cold blue-black tone.

When the same negative was printed on Agfa Protriga Rapid paper and developed in Selectol developer the shadows produced more detail; the overall image went to a brown-black tone that warmed it up considerably. There was no noticeable difference in contrast or in the highlight tones of the print. The warming effect takes place more in the shadows.

3

Papers and Chemistry

Photographic papers come in a large variety of surfaces, textures, bases, image tones, and weights. Many photographers combine their materials based on information usually found in the *Kodak Data Guide* for the black-and-white darkroom, but few ever really take their materials and mix them in different developer/paper combinations and discover the different results that can be obtained. In this section, some new combinations will be explained and their effects shown. The hope is that this will increase your interest in trying your own combinations and developing a more personal style.

NATURALLY TONED PAPERS

The paper surfaces that are available are commonly known as glossy, semi-matte, and matte. Certain characteristics accompany each. Glossy surfaces tend to be more contrasty than their equal-grade counterparts and have better detail and tone separation. Their biggest drawback becomes evident when you try to retouch a glossy surface. Much time and patience is required to do a good job of retouching because the dyes and brush strokes are more noticeable on this surface, an undesirable effect.

Semi-matte paper surfaces are often the popular choice for enlarging. They have a more subtle tone separation and a bit less separation of detail. It is much easier to retouch prints made on this surface; this decreases the print-making time from beginning to end.

Matte surfaces are much duller and flatter than most printers prefer but will work well with high-contrast negatives.

Base tone or tint refers to the color of the paper stock and is usually expressed in terms of cold, warm, or neutral. The basic color of the base is white, but this can vary from a cold fluorescent tone to a warm, brownish cream. This affects the image tone, which refers to the color of the silver image after the print is developed and completely dried. The determining factors in image tone are the developer's type, temperature, and dilution and the development time, fixing time, and drying temperature.

A chemical's dilution can change the contrast level of the paper by as much as half a grade. This is very useful for prints that seem too low in contrast on a grade 2 paper, say, and too high on a grade 3. The best grade would be about a 2½. Although it is possible to obtain grade 2½ when working with Polycontrast filter kits and Polycontrast papers, you may not want to use that alternative. If Polycontrast paper is not your favorite, try changing the dilution of your developer instead. A more diluted developer used with a grade 3 paper would give a result closer to grade 2½. Alternatively, use an undiluted developer with a grade 2 paper to obtain a similar yet slightly different result. Only by trial and error will you find the situation that will work best with your particular negative and photographic paper.

The developer's temperature will also have a noticeable effect on the image

When this print was made on Protriga Rapid paper and developed in Dektol, the feeling of night and cold mist was lost. The shadows characteristically opened up a little and the highlights became too muddy. I wanted a colder tone than the soft brown-black that was produced.

tone. For each developer there is a temperature at which the most effective results are obtained. Most developers contain hydroquinone, which will react poorly at temperatures below 65°F. Therefore, it is best to work at about 68°F. A slightly higher temperature will increase the developer's activity and shorten the development time. It is important to remember that a higher temperature will also require more careful handling of the paper because the emulsion will be more susceptible to scratches and cracking. Using a developer at 70 to 75°F will sometimes bring out a bit of detail in a highlight area that would not print with straight exposure. It is sometimes preferable to burn-in that area during printing because the hotter developer will often also turn the whites a dirty gray. You must remember that a temperature change of two to five degrees will alter the contrast of the image as well. By making a few test strips and exposure adjustments, you will soon find the temperature level best suited to your situation.

There are three types of printing papers: chloride, bromide, and chlorobromide. Chloride papers are made with a silver chloride emulsion and are usually slower in speed. They are best suited for contact printing and will work well with high-contrast negatives. The problem is that they also have a poor reproduction quality of tone gradation, which will also affect the visible amount of detail in the shadows.

Paper name	Purpose	Type	Base	Speed	Tone	Color	Developed in Group I	Group II
Agfa Brovira	enlarging	bromide	fiber	high	cold	cold/neutral black	cold black	neutral
Agfa Protriga Rapid	enlarging & contact	chloro-bromide	fiber	high	warm	olive/brown black	neutral black	warm
Kodak Azo	contact	chloride	fiber	slow	warm	warm/neutral black	neutral black	warm
Kodak Kodabromide	enlarging	bromide	fiber	high	cold	neutral/cold black	cold black	neutral
Kodak Polycontrast	enlarging & contact	chloro-bromide	fiber	high	neutral	neutral/warm black	neutral black	warm
Kodak Ektalure	enlarging & contact	chloro-bromide	different surfaces different base	medium	warm	warm/brown black	neutral black	warm

Bromide papers are silver bromide emulsions that are about 100 times faster than chloride papers. This type of paper is a common choice for enlarging because of its faster speed, which decreases the amount of exposure time necessary. Chlorobromide papers are a combination of emulsions. They are moderately fast, about 20 times as fast as chlorides, and can be used for both contact printing and

Developers in Group I

NEUTRAL/COLD TONES

Dektol
D-72
Versatol
Ektaflo Type I

Developers in Group II

WARM TONES

Selectol
Selectol-Soft
Ektonol
Ektaflo Type II
D-52

Mix it Yourself

D-72

water 50°C (120°F)	500.0 ml
metol	3.0 grams
sodium sulfite (anhydrous)	45.0 grams
hydroquinone	12.0 grams
sodium carbonate (monohydrated)	80.0 grams
potassium bromide	2.0 grams
cold water to make	1.0 liter

Standard: dilute 1 part stock with 2 parts water; develop 1 minute at 20°C (68°F).

D-52

water	500.0 ml
metol	1.5 grams
sodium sulfite (anhydrous)	22.5 grams
hydroquinone	6.0 grams
sodium carbonate (monohydrated)	17.0 grams
potassium bromide	1.5 grams
cold water to make	1.0 liter

Standard: dilute 1 part stock with 1 part water; develop 2 minutes at 20°C.

The same print made on Brovira paper and
developed in Dektol is shown here. The
Dektol was diluted 1:1 instead of the normal
1:2. This increased the developing speed time
and the separation between the shadows and
highlights came up quicker. The blue-black
tone is more of the feeling that I had hoped to
produce in the beginning.

This neutrally toned print was made on Brovira and developed first in Selectol-Soft for one minute and then in Dektol for one minute, both with standard dilutions. This equalized the tone quality of warm and cold to produce gradation and shadows with deep blacks.

enlarging. This type of paper has good tone separation and is also a common choice for printing.

In the data that follows, types of papers and their inherent image tones, as well as their purposes and speed ratings, are listed. Following that is a list of developers and the resulting effect each will have on each paper. The combinations of paper and developer will have varying and often undeterminable effects depending on the number of variables involved, such as temperature, dilution, development time, and paper grade.

PUSH PROCESSING AND RECORDING FILM 2475

From time to time, photographers find themselves in a situation where the film speed is not fast enough to record the image. This is very typical of sports events or parties that take place inside and under very low light conditions. To record the information, certain compromises in image quality must be made in order to obtain a shutter speed that will prevent the blurring of the subject.

A solution to the problem is to choose the shutter/aperture combination that will produce a clear representation of the subject and then find the matching exposure index on the ASA selection ring. In effect, what you are doing is underexposing the film. This will require an increase in the development time to compensate for the lack of light exposure to the film. Grain and sharpness will be affected, but this is the compromise you must make to record the image. On the other hand, this compromise can sometimes produce an image that is useful and interesting as a special effect—a dreamlike, misty photo.

If, for example, you have underexposed your film by one stop, an increase of one-and-one-third times the recommended development time should be used as a starting point for determining proper development. Two stops under will re-

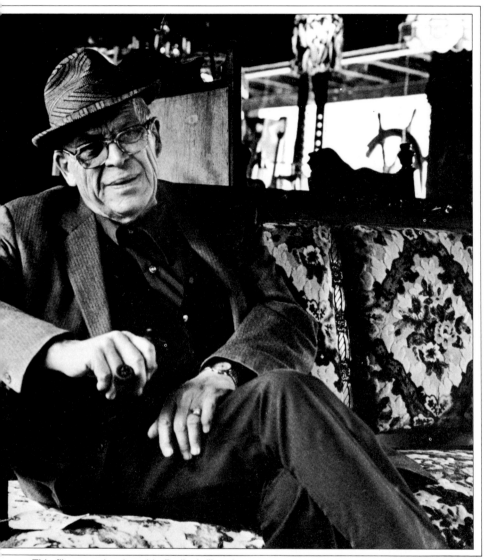

This film was developed in Rodinal diluted
1:50 because the roll of Tri-X was exposed
at an exposure index of 800. This meant
that there had to be some correction in the
development to compensate for the
under exposure. Rodinal is a good developer
for this because it minimizes the grain
increase that is characteristic of push
processing.

Normally processed film produced this print, which lacks depth of field and contrast.

Grain is more noticable here, as is the increase of contrast and depth of field.

This shot was developed in DK-50 for five minutes at 70°F. The grain structure is considerably softer and the contrast is very flat. Recording film is good for shots where there is no other choice or where there is a special effect in mind. *Photo by Michael Wade Blatt.*

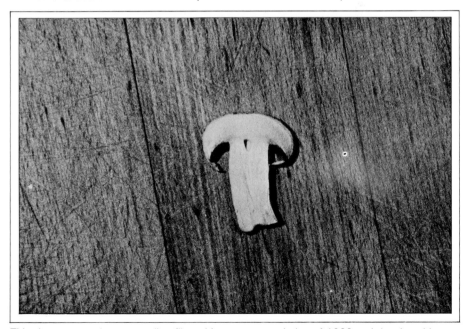

This shot was made on recording film with an exposure index of 1000 and developed in HC-110, Dilution B, for eight-and-a-half minutes at 70°F. The contrast and grain are noticably higher, which is better for a special effect. *Photo by Michael Wade Blatt.*

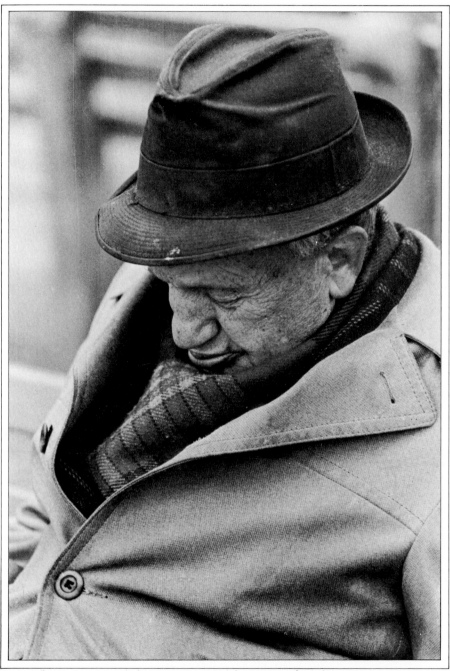

This roll of film was developed in DK-50 at 65°F for 11 minutes. The contrast is comparable to standard films; the grain structure is similar to Tri-X pushed. Remember that recording film produces more grain as the exposure index and development time increase. *Photo by Michael Wade Blatt.*

quire one-and-a-half times more development, and so on. For this reason it is much more sensible to push a film of ASA 400 rather than ASA 125 film, unless you are aiming for a special effect. Pushing Kodak Tri-X film is the most common situation. Because of this, various companies have determined push-processing times for their developers and Tri-X. The box below, for example, gives recommended development times for Agfa's Rodinal developer.

Agfa Rodinal Developer

E.I.	Dilution	Development Times (Minutes)		
		65°F	68°F	72°F
600	1:75	18.5	15.5	12.5
800	1:50	19	16.5	13.25
1200	1:65	21	17.5	14
1600	1:50	22.5	18.5	14.5

An alternative to push processing is the use of Kodak's 2475 Recording Film, with an exposure index of 1000. It produces a fairly grainy image, but this can be controlled by the use of different developers. This film is very popular in law-enforcement work and is an extremely high-speed, panchromatic film with an extended red sensitivity. The 0.10 density base helps to minimize edge-fog and provides protection against halation. It is available in 16mm, 35mm long rolls, and 135mm magazines.

The lighting situation best determines the exposure and development of this film. When working at E.I. 1000 in below-average light contrast, develop in DK-50 for six minutes. If the lighting situation is high contrast, develop in DK-50 for nine minutes at 68°F. This will produce an image with flatter contrast and softer grain.

For higher-contrast negatives with sharper grain, it is best to use HC-110, Dilution B for nine minutes in average-contrast situations and for 15 minutes in low-contrast situations.

If an exposure index of 1000 is not enough, this film can be pushed even higher with useful results. An E.I. of 1250 developed in DK-50 at 68°F for five minutes is a good starting point. Remember that any development time under five minutes can cause uneven development and overall poor results.

After development, rinse in a stop bath for 30 to 60 seconds at 65 to 75°F. Agitate the film constantly for best results. Fix for eight to 12 minutes in normal fixers or three to five minutes in rapid fixers at 65 to 75°F. Wash thoroughly for 20 to 30 minutes at 65 to 75°F in a running-water bath.

INFRARED FILM

Infrared film is a fascinating film for creating special effects without too much mess and extra materials. In industrial applications, it is used for various types of scientific, medical, and documentary photography, as well as photomechanical and photomicrography work. Creatively used, it allows the photographer to produce a dreamlike fantasy image because it records the tones of objects differently than panchromatic film. This tone shift is due to the film's sensitivity to some visible light as well as to imperceptible infrared radiation.

Infrared film is produced by Eastman Kodak and is called High Speed Infrared Film. It is available in motion picture sizes, 16mm and 35mm still photography cassettes, bulk rolls, and 4 × 5 sheets. The infrared Aerographic Film 2424 is basically the same emulsion but is also available in 70mm, 5″ and 9½″ rolls.

When working with infrared film, remember that there is a difference in focusing for infrared and visual wavelengths. This is because infrared radiation is made up of longer wavelengths than visible light, and conventional cameras are not designed for infrared light. Since infrared wavelengths are slightly longer than the

In this example of infrared film you can see the grain size fairly well. This roll of film was developed in D-76 diluted 1:1 for a little less grain than usual. I used infrared because it was a misty, rainy day and the grain size helped emphasize the mist. No filters were used, but even so the result does not resemble normal panchromatic film.

visible light waves, the focusing distance from the subject to the film plane needs to be adjusted. A glass lens refracts the longer wavelengths to a lesser extent than visible light, causing them to come into focus farther from the lens.

Almost all cameras have a red mark to the right of the visual focus mark on the barrel of the lens, along with the focusing scale. After obtaining a sharp "visual" focus, the indicated distance is shifted to the infrared focus mark on the right. This adjustment is not that important when using small apertures or a wide-angle lens.

If you are working with a view camera and infrared film, the focus is corrected by adding 0.25 percent of the focal length to the lens-to-film distance. This is actually the same procedure followed with a 35mm SLR camera, but the manufacturer has already calculated the 0.25 percent by calibrating the red mark.

Film cassettes are not opaque to infrared radiation, so load and unload the film in complete darkness. To check that you've loaded the camera properly, while in the dark, feel to make sure the rewind knob moves each time you advance the film. You will find it useful to carry a changing bag along with you when shooting out on location. The 35mm film only comes in 20-exposure cassettes, so you may need to change rolls often. Not all changing bags are opaque to infrared radiation; check yours before you are out in the field. You must also remember that infrared films are susceptible to fogging from long exposure to heat. Don't leave film rolls in the glove compartment of a car or in direct sunlight. It is much better to keep them in the refrigerator and remove them about one hour before use.

Because a characteristic of infrared film is that it is sensitive to both visible light and infrared radiation, filters can be used to manipulate the final result. This is done by using filters that allow control of the varying amounts of each.

A #87 (red) filter allows only infrared

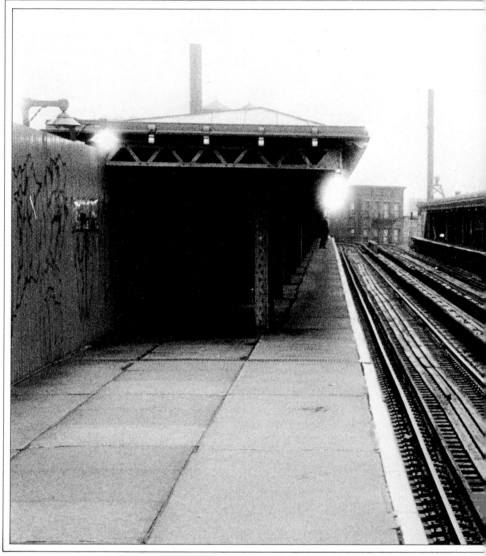

This shot, taken on infrared film without filters, shows the special infrared effect around the lights. They wash out to produce clean highlights and are a little misty.

radiation to pass through. Therefore, objects reflecting the most radiation appear lightest in tone. If you are working with a 35mm SLR camera, the #87 filter will have to be removed to focus because the filter appears very opaque to the eye.

A #25 (red) filter will prevent blue and green light from reaching the film but transmits red and infrared radiation. This filter will show more conventional reflectivity. You can focus through this filter, which is an advantage over the #87 (red) filter.

The #58 (green) and #12 (yellow) both allow different segments of visible light to pass through, along with infrared radiation. Both have slight effects on the highlight regions of the final negative, mainly the sky.

Even though the film's sensitivity is meant for infrared radiation, as well as some visible light, working without a filter will not necessarily produce an effect similar to that of the panchromatic type films. Because the proportion of visible light to radiation will be at its highest point without a filter, foliage will be lighter than normal and skies will be darker.

Haze penetration is also possible with infrared film because haze is part of the opposite end of the light spectrum (ultraviolet). A #25 or #87 filter and a polarization filter is the best combination. The polarization filter removes the blue part of the visible light spectrum and enhances the infrared effect.

To determine the proper exposure, start with a hand-held meter set at ASA 50 for daylight situations. Adjust the camera according to the indicated exposure from the hand-held meter, regardless of the filter over the lens. Remove the filter each time you make a reading using a TTL metering system and bracket one stop in each direction to ensure correct exposure. Overexposure by about three stops will produce a soft, grainy image. Underexposure by two or three stops will block up the shadows and produce a relatively flat

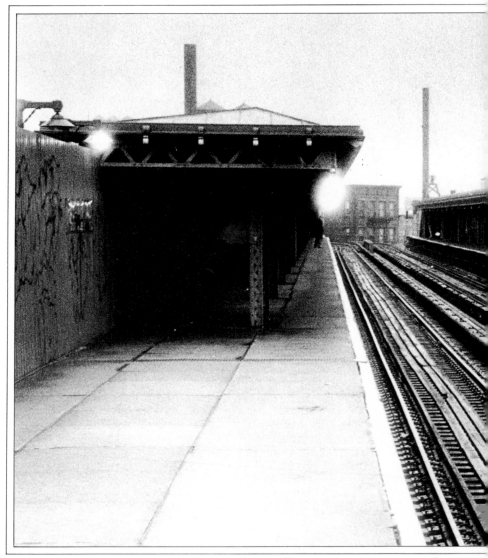

A #12 yellow filter has slightly increased the sky density; the platform starts to wash out because of the infrared light being picked up. A #87 red filter would have increased this effect a bit more, particularly in the sky area.

negative. There is an approximate difference of three stops between the infrared radiation of the seasons of the year.

Use the chart below for determining the starting exposure index.

Conditions	Daylight	Tungsten
without filter	80	200
#25, 29, 70, 89B	50	125
#87, 88A	25	64

The information below is for the development of Kodak's High-Speed Infrared Film. The film should be handled carefully because it is very susceptible to scratches. Static electricity is also a problem with infrared film. It can build up on the pressure plate of your camera and cause pinholes in the film. To avoid this situation, simply coat the pressure plate, in the back of your camera, with a small amount of Photo Flo on a cotton swab. This should keep your pressure plate static-free for about a month.

Processing High-Speed Infrared Film.

1. Presoak film for 2 minutes at 20°C (68°F).
2. For a grainy negative, develop in D-76 for 11 minutes at 20°C; for less grain, develop in D-76 1:1 for 11 minutes at 20°C. For higher contrast and more grain, develop in D-19 for 6 minutes at 20°C. This will cause the highlights to wash out. Rinse, fix, and dry as normal.

Another creative use for infrared film is with flash. When a #87 red gel is placed over the flash unit, it is impossible for the subject to notice. This is very useful for producing spontaneous, unposed shots at parties or in any other public area where a flash would make the subject self-conscious or conspicuous. You can also place a #25 filter over the lens instead of over a flash and obtain similar results.

This roll of infrared film was developed in undiluted D-76. The grain is much larger and more noticeable. This effect increased the softness of the mood and provokes a more mysterious effect than the others. The child is blurred because of his movement during the time of exposure. *Photo by Ann Brandeis.*

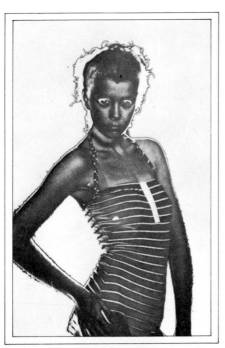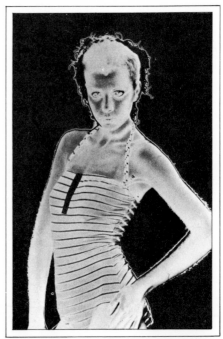

The Sabattier effect was achieved by using
Kodak Super XX film and developing in
Dektol 1:2, with constant agitation for the
first minute and a half. A flash was set off
about four feet directly above the tray; the
film was then developed for another minute
and a half. The Mackie lines are very
pronounced in this example. Flash output
was determined by trial and error.
Photo by Michael Wade Blatt.

This reversal of the print on the left was
done by contact printing the first result onto
another sheet of Kodak Super XX film at
f/16 with an exposure of one-half second.
The print was then developed in Dektol 1:2
for three minutes, with constant agitation.
Photo by Michael Wade Blatt.

4

Solarization and the
Sabattier Effect

The reexposure of any photo emulsion, whether paper or film, is often referred to as solarization. This is not totally accurate. There are actually two different processes of reexposure, solarization and the Sabattier effect, and both produce slightly different results.

Many darkroom beginners have "discovered" solarization accidentally, because of overeagerness. It usually happens somewhat like this: While the print is still in the developer, white light is accidentally and momentarily turned on. In the hope that no damage has been done by the light, development is continued. In fact, however, the emulsion on the developing print has been reexposed; the resulting image seems to be a mixture of a positive and a negative. Although technically "wrong," it is also definitely interesting as a special effect. Take creative advantage of it.

What happened was that a chemical reaction took place. Because the development was incomplete, the silver halide crystals in the highlights were underexposed and slightly underdeveloped and still remained light-sensitive. When reexposed, they were turned into metallic silver. Their darkness at this point depends on the amount of reexposure and redevelopment they received the second time around. The silver halide crystals in the shadows are only slightly affected by the reexposure, however, because they have already been changed into metallic silver through the first exposure and development process.

SOLARIZATION

When deliberately causing solarization, there are many variables to consider. The first is the amount of reexposure the print needs to acquire a pleasing positive/negative image without going totally black. You'll find this time through experimentation, using your own light source. The contrast of the paper is also a variable. Higher-contrast papers work much better than lower-grade papers because they tend not to fog as easily. Higher-grade papers also contain more silver and thus produce a stronger negative/positive image. The amount of development and then redevelopment also control the final result. Control of all of these variables can only be learned through experimentation with your equipment and materials. A good starting point, including development and reexposure times, is the procedure outlined in the box below.

SABATTIER EFFECT

Another process for obtaining a positive/negative image is the Sabattier effect, which is often confused with solarization. Both processes involve reexposure and redevelopment, but the Sabattier effect is created on the film, not the print. Because the Sabattier effect is on film, it is possible to reproduce the same result again and again. The drawback is that when working with 35mm film, it is necessary to reexpose and process the entire roll of

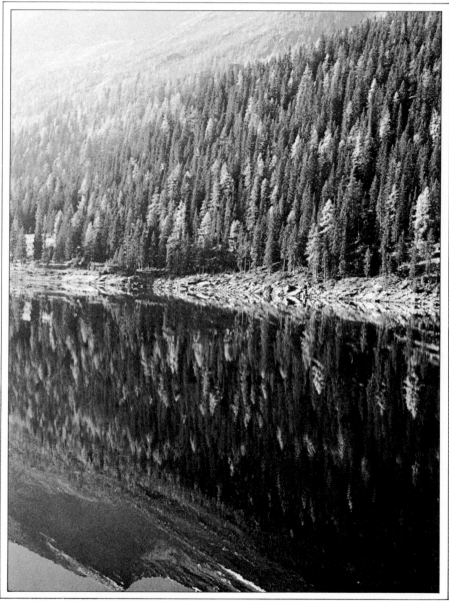

Although this print shows interesting symmetry, the tones are somewhat too dark at the top. The mirror-image idea the photographer was seeking doesn't really come through.

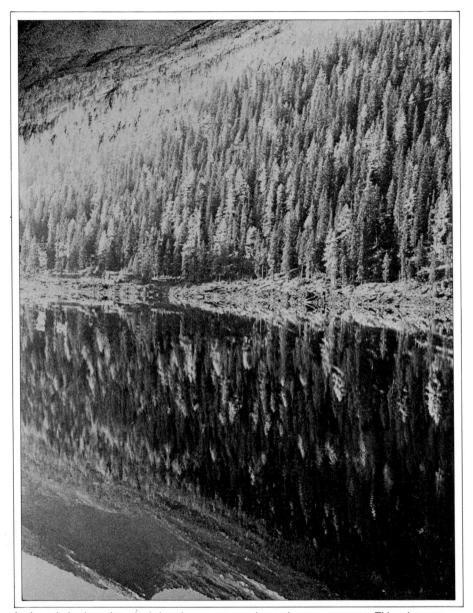

In the solarized version, the mirror-image concept is much more apparent. This print was developed for 45 seconds in Dektol 1:2 at 68°F. It was then placed under the enlarger at a wide-open aperture and exposed to white light for about three seconds. The print was then returned to the developer for another 45 seconds and processed normally after that.

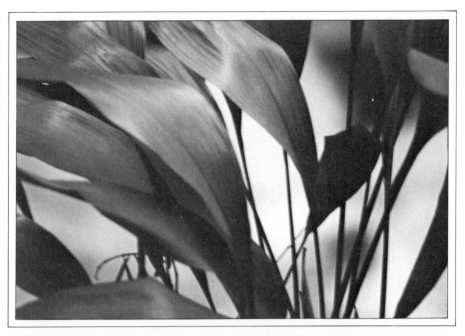

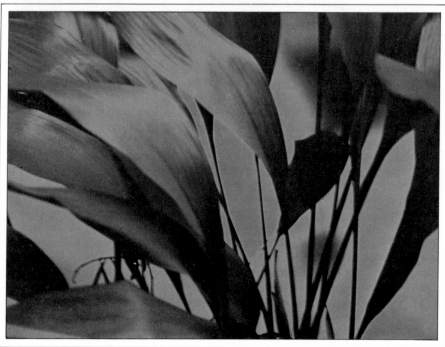

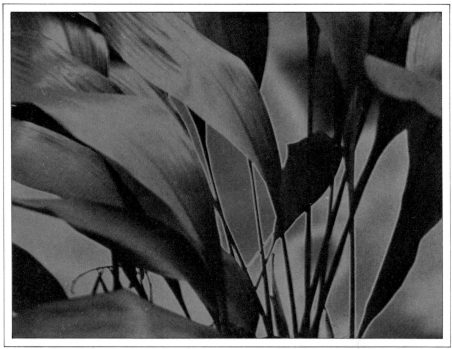

This sequence shows the effect reexposure has on the original print (above left). The print was made on Ilfobrom grade 4 paper. The reexposure time for the first Sabattier photograph (below left) was three seconds at f/11 with an enlarger height of 22 inches. The second Sabattier print (above) has a reexposure time of five seconds. Notice that the outline of the leaf becomes more defined. Reexposure times will depend on your enlarger type, the age of your enlarger bulb, the dilution of your chemistry, and the type of paper you are using.

film. Because of this, it is much better to work with larger negatives that can be re-exposed one at a time, such as the 4 × 5 film sizes. Make more than one properly exposed negative of your subject. This will allow you to experiment with reexposure in the darkroom to get the effect you desire.

A characteristic that is much more distinct in the Sabattier effect than in solarization is the line that forms around parts of the image that have sharply defined edges; this is known as a Mackie line. Because an emulsion's silver halide crystals undergo a chemical breakdown during normal processing, there is naturally a buildup of metallic silver in those areas that have received more exposure and are now partially developed. During reexpo-

sure, these partially developed areas block out some of the light and therefore create another image superimposed on the first. The edges of the image between the fully and partially developed areas are where the Mackie lines occur.

A good film to use for the Sabattier effect is Kodak Commercial Film 6127. Available only in sheets, this film is normally used for copying continuous-tone black-and-white originals because it has a moderately high contrast with very fine grain and a high resolving power. This film is orthochromatic, so it is possible to process under a red safelight; an image will appear after 40 seconds of development in DK-50. After reexposure, the film will turn completely black. Do not remove it from the developer until the full

development time or two minutes has passed. It will lighten and clear during fixation.

The box below outlines a step-by-step process for obtaining the Sabattier effect using Kodak Commercial Film 6127 and DK-50.

Use this test exposure to determine the amount of solarization you want for your print. Keep in mind that to obtain the same result twice is very difficult owing to the number of human variables involved. You can come close, but don't expect identical results.

In the original print of this chimney and brick wall, the sky was washed out and blank, making the Mackie line effect very visible when the print was solarized. The procedure was the same as for the print on page 87.

Solarization

1. Make a properly exposed print from your negative.
2. Place into developer with the timer set at 90 seconds.
3. After 30 seconds of constant agitation, remove the print, allow it to drain momentarily, and place into dry, extra tray.
4. Place tray with print, face up, under an enlarger with the diaphragm open all the way and make an exposure test at intervals of three seconds.
5. Return the print to the developer for the remainder of the processing time.
6. After the total 90 seconds of development time is up, stop bath, fix, and clear as normal.

Sabattier Effect

1. Make a test exposure with the film and developer to obtain a normal negative.
2. Develop negative in Kodak DK-50, undiluted, for 2 minutes with constant agitation. Stop, fix, wash, and clear as normal.
3. After obtaining proper exposure for a normal negative, expose the film for your subject and process in DK-50, undiluted, for 30 seconds with constant agitation. Make sure the film is in the developer emulsion-side up.
4. After 30 seconds of development with constant agitation, allow the negative to settle on the bottom of the tray for 10 seconds. Leave it emulsion-side up, with no agitation.
5. Reexpose the film while it is still in the developer. Only experimentation with your light source will give you the proper reexposure time, but 2 to 5 seconds is about the range.
6. After reexposure, turn off white light and develop the film for the remainder of the 2 minutes with constant agitation.
7. After development, stop, fix, wash, and clear normally.
8. Make a standard print on a grade 3 or 4 enlarging paper.

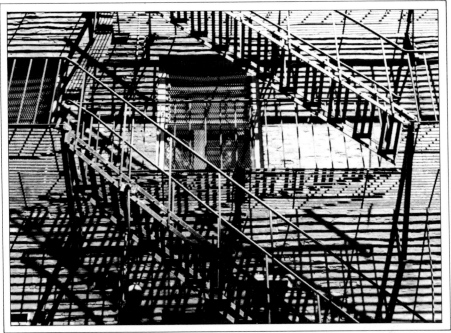

The Sabattier effect was perfect for this photograph (above) to produce a very graphic translation. Reexposure time for the photo below was four seconds at f/16 with an enlarger height of 15 inches on Ilfobrom grade 4 paper.

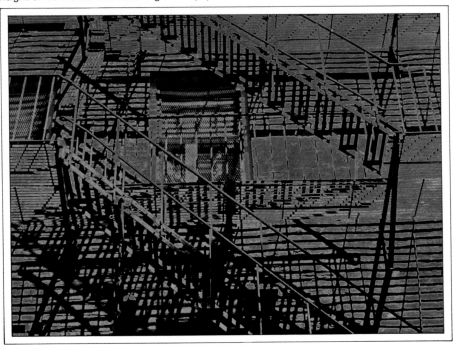

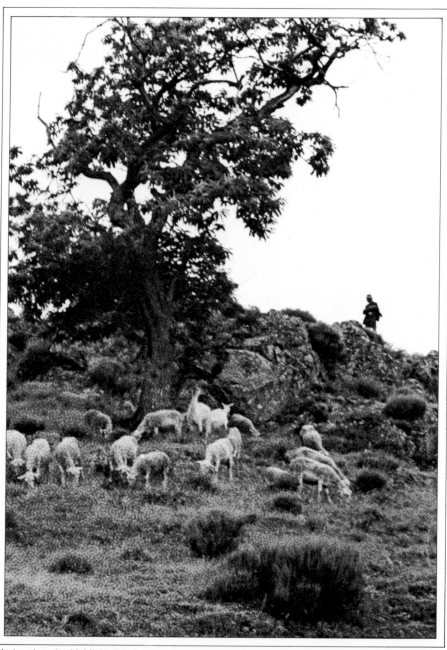

Notice that the highlight (sky) areas do not show the effect of reticulation as much as the heavier density areas. The temperature change was again about 30°F. The cracking effect gives the overall print a very aged feeling. This seemed right to me because shepherds have been around a long, long time; this shepherd, in particular, for 50 years.

5

Reticulation

The crazed patterning on prints created by reticulation is often regarded as a mistake caused by lack of enough attention to the consistency of the processing chemistry. A temperature change of as little as $\pm 5°F$ during processing can crack the emulsion of a negative, causing reticulation, often mistaken for grain. However, reticulation can be created deliberately to enhance a photograph. Although there is no exact way to control the cracking pattern in the emulsion, you can become fairly familiar with what to expect.

Reticulation was a common fault in early film and glass-based negative emulsions because of the instability of the materials used to make the film. These instabilities have been greatly reduced through advanced technology in both film and processing. Modern films have built-in protection against reticulation. In addition, the introduction of hardeners (potassium alum) into the fixer, and/or to stop the bath (potassium chrome alum), protects the emulsion from swelling and then contracting during processing. This eliminates what is often the primary cause of reticulation.

To create reticulation you need only vary the temperature between the developer and stop bath by more than $\pm 5°F$. In this example, Tri-X 35mm film was used, processed in HC-110, Dilution B, at 68°F for seven minutes. The temperature of the stop bath was then increased to 110°F and the film soaked for 30 seconds with only five seconds of agitation at the very beginning to give an even coating to the film. Straight water was used instead of Kodak SB-1 or SB-3 stop bath to avoid the hardener. Then a 68°F fixer solution without hardener was used for five minutes. The rest of the procedure was standard: 68°F water wash, 68°F hypo clear, 68°F Photo Flo, and hung to dry.

Reticulation by this method is easier and obtains the most useful size pattern. The only drawback to this method is that once you have reticulated a negative, the effect is irreversible.

In the case of 35mm film, it is also difficult not to reticulate the whole roll by the above method. There is, however, another, more complicated method of reticulation that uses processed negatives, individually if you wish. In this process sodium carbonate, a common accelerator that activates the developing agent, is used as the primary chemical in the developer formula. The sodium carbonate actually eats the protective coating on the emulsion. The chemical is mixed with 30 g of sodium carbonate to 500 ml of water at 60–65°C. This solution is then placed into a small tray and the film is immersed for five to 20 minutes, depending on the extent of reticulation desired. The film is then rinsed off in cold water.

This method is somewhat more involved and requires a little special chemistry. But it is not really any harder than the first method and can be utilized on old negatives, allowing you to select particular negatives from an already-processed roll of film.

The patterning seen on a reticulated

print is particularly effective for conveying an aged feeling. Because the effect is fairly subtle, try to choose negatives that have open areas, such as expanses of grass or foliage, so that the effect is noticeable. Reticulation will not be visible on a contact-sized print. Make an enlarged print from the negative and then use burning-in techniques to emphasize the pattern in the highlights.

Method 1

To reticulate unprocessed negatives

1. Develop normally at 20°C (68°F) for the recommended time.
2. Do not rinse the negative in a stop-bath solution. Rinse in heated plain water at about 44°C (110°F).
3. Add fixer solution without hardener at 20°C.
4. Complete processing, using standard procedures.

Method 2

To reticulate processed negatives

1. Mix 30 g of sodium carbonate with 500 ml of water at 60–65°C (140–150°F).
2. Immerse the negative in this solution for several minutes.
3. Rinse negative thoroughly in cold water.

The temperature change from the fix to the
first wash was about 30°F. I felt the
cross-hatched effect would enhance the
feeling of being in the weeds, which is
where I had to go to get the picture. At the
same time the reticulation also emphasized
the aged, cracking boat, by giving the print
an overall cracked texture.

Reticulation shows up best when the negative has some dense areas, as this one does. Developed in D-76, 1:1, at 68°F, the negative was then placed in a water wash at about 95°F. The temperature change produced a large amount of obvious reticulation.

This graphic print was the result of a contact print from a Kodalith high-contrast negative printed on Agfa Brovira grade 4 printing paper. The image was made stronger in terms of print quality when all the tones were reduced to only black and white. The Kodalith positive was opaqued to help achieve the drastic difference between the tones.

6

High-Contrast Printing

In all high-contrast printing, continuous-tone negatives (negatives that contain every shade of gray between pure white and solid black) are converted to nongradated tone images in black and white only. All the intermediate gray shades are eliminated. The result is a striking, highly graphic print. However, not every negative is suitable for high-contrast printing, since the final print no longer has a wide range of tones to separate the different images in the photograph and provide a sense of depth and space. A good starting point for a high-contrast print would be a strong, back-lit composition. Stay with simple subjects and avoid elaborately detailed pictures.

Kodalith Ortho Film 2556, Type 3, is the most common high-contrast film used for these special effects. It comes in a 35mm size, which may appeal to many, but in most cases it is preferable to use a larger film size, such as 4 × 5, for easier handling during processing. Ortho Film 2556 is very high contrast and has good image definition, otherwise known as acutance. If one were to define the contrast level of this film with a grade number, such as those used for photographic printing papers, grade 20 would be close.

Because Kodalith film is orthochromatic (not sensitive to red but sensitive to ultraviolet, blue, and green light), it is possible to work under a standard 1-A red safelight without affecting the film. This allows for easier determination of the film's proper exposure and processing time. General handling of the film is also much easier. The chance of fingerprints on the final piece of film is thus greatly reduced.

There are a number of Kodalith film developers on the market; recommended are Kodalith Super RT and Kodalith Fine Line by Kodak. (Fine Line gives a slightly finer grain.) These chemicals come in ready-to-mix form and in various package sizes. The litho developer is mixed in two separate parts, A and B. To produce a working solution developer, equal parts of A and B, stock solution, should be mixed just before use. Their developing quality exhausts within 30 minutes at a rate determined by use. Separately, however, these chemicals, when properly closed and stored, will last indefinitely.

Processing times will vary with the type of developer that is used. Along with the film package, you will find the recommended developers and times for processing. No matter which developer you use, the development time should be between two and three minutes, with continuous agitation. These times are critical; overdevelopment will cause the loss of fine detail, and underdevelopment will prevent the black tones from reaching their correct density. After development, a normal stop bath of 15 seconds and a fixing time of four to five minutes should be used. Keep the chemistry temperature at 20°C. Wash the film for 10 minutes, in running water, then soak in Photo Flo for one minute and hang to dry in a dust-free location.

The way in which the sun hit certain leaves of this tree was very interesting. The effect was not noticeable enough in the original print, so I made a high-contrast Kodalith negative and opaqued certain areas I wanted to block up. This helped call attention to the leaves in the sun by clearing out all the other leaves and exaggerating the sun's effect.

TONAL DELETION

A very simple effect in high-contrast printing is commonly referred to as tonal deletion. The process involves taking a continuous-tone negative or positive, which has a full range of tones, and reducing it to only two tones, black and white. It's important to remember that the final print has only two very graphic tones that must define the shape of the image in the photograph. Not all negatives, when reduced to these two tones, will give a good image, but through trial and error you will learn which ones will. Try starting with very simple composi-

tions and work your way from there. Stay away from elaborately detailed negatives or those with a narrow tonal range.

The exposure given to the Kodalith will determine the final tone separation. When making a high-contrast negative from a positive, remember that a long initial exposure (five to eight seconds) will produce an emphasis in the highlight areas on the final print. A short initial exposure (two to four seconds), therefore, will give emphasis to the shadow areas on the final print. To obtain a Kodalith that has both shadows and highlights, your exposure should be somewhere in between.

If you have a negative, either a con-

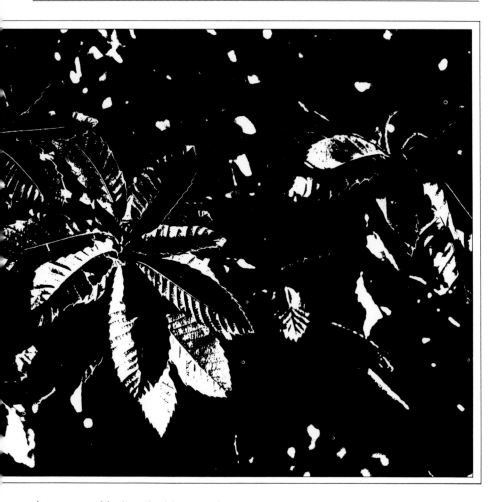

tinuous-tone black-and-white negative or a high-contrast Kodalith negative, and you desire to make a high-contrast positive, a long initial exposure will produce more detail in the shadow areas; a short initial exposure will give emphasis to highlights on the final print. Again, an exposure in between the two extremes will produce the best results.

For a tonal deletion from a color or black-and-white transparency, simply enlarge or contact-print it onto the Kodalith film to get a high-contrast negative, then contact-print the negative with the printing paper to get an effective high-contrast print.

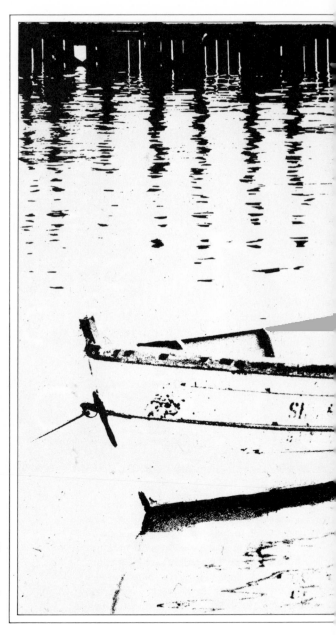

To retain some gray in a tonal deletion, dodge the picture. Some gray is present in the boat in this picture, for example, because that part of the print deliberately was given less exposure.

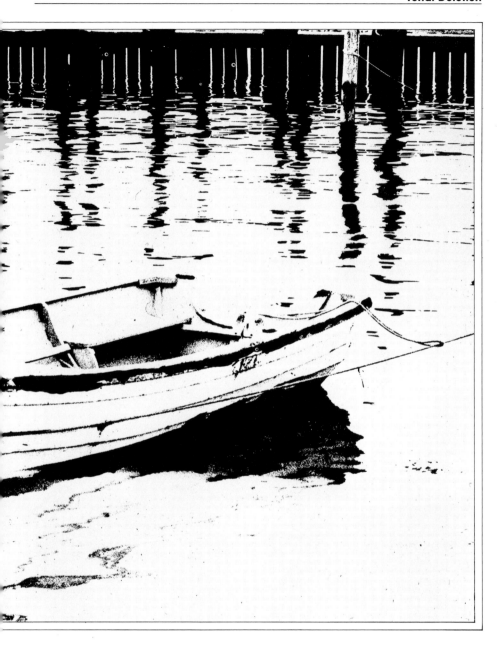

To get a wide tone-line effect, as in this photo (overleaf), place the two Kodaliths base to base. For an even wider line, place a sheet of acetate between the Kodaliths. This shot was opaqued slightly to give more definition to the shapes.

TONE LINE

The tone line effect is created by printing the product of a sandwiched Kodalith negative and positive from the same image. The final product is the image of a continuous-tone negative with only black and white tones. There are no mid-tones to deal with, and the effect is that of a line drawing.

POSTERIZATION

Using the powerful graphic effect of posterization, a continuous-tone image is reduced to one with just three condensed tonal values: white, gray, and black. The absence of gradation produces a poster-like effect, created by separating the continuous-tone image into three masks of different densities, using Kodalith film. The Kodalith negatives are then combination-printed in register to produce the final print.

Because Kodalith film processed in Kodalith A and B developer reduces a wide range of continuous tones to sharply defined areas of white, black, and gray, it is ideal for posterization. As with other techniques using Kodalith, 4 × 5 sheets are preferred for ease of handling, particularly in posterization, where accurate registration is crucial. (See page 99 for more information about Kodalith film.)

PIN REGISTRATION

For making a posterization, registration is important. Each density mask must line up exactly, both when making the separation from your original image and again when making the final print. This is usually done with a pin registration board.

Pin registration boards can be purchased, but it is very easy and certainly cheaper to make one yourself. You need a standard office paper punch (¼-inch holes), a piece of board about 5 × 6 inches in size and painted flat black, and

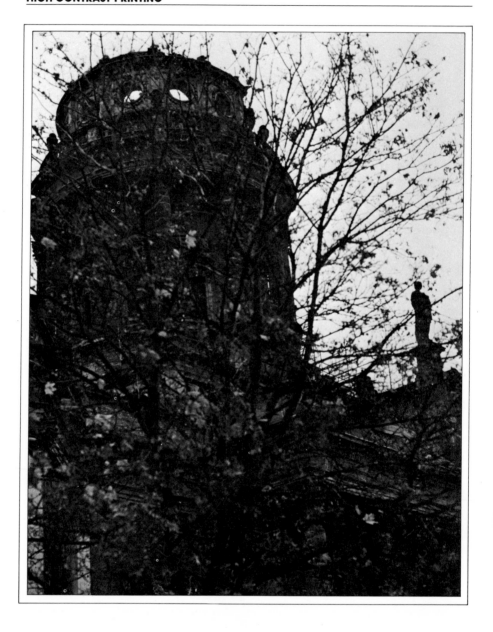

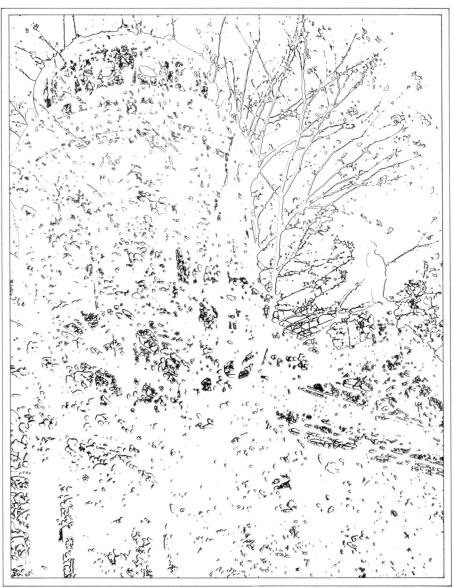

It took me a while to find the right medium to use to produce this photograph. I wanted the statue in the photograph at left to be more noticeable, but not by standard burning and dodging. I felt that this photograph deserved something more exciting, as shown above. By placing Kodalith negative and positive tone deletions together, base to base, and sending light through at a 45-degree angle, I was able to remove the dark forms of the tree branches and building to isolate the statue. Some opaquing was necessary around the statue.

a set of Bergman Q-3 register pins or the equivalent. Bergman register pins are available from printing-supply stores and are fairly inexpensive. Each pin is ¼-inch in diameter and ¼-inch high.

To make the pin registration board, use the paper punch to make two holes in the four-inch side of a scrap piece of 4 × 5 Kodalith. Align the registration pins with the holes in the film. When the spacing is exact, tape the pins down on the base board, using black photo-tape. By painting the base board flat black and using only black photo-tape, you will avoid halation or from reflected light.

Do not adjust the spacing of the holes in the paper punch or of the registration pins from now on. Everything will be punched and registered on the base board according to this sizing.

MAKING THE SEPARATIONS

To make the tonal separations, first focus the enlarger, with your continuous-tone negative, onto the base board with the registration pins. Be sure not to bump the base board after the focus is set. If at some point you do, you will have to go back to the beginning and start again. Exact registration is vital. You can use black photo-tape to tape the board to your work surface.

Next, take a piece of unexposed Kodalith film and punch holes in it to fit the registration pins. Then place it onto the base board, emulsion-side up, and find the minimum exposure necessary to print through the highlights in the negative. This will give you a separation mask that is totally clear where the highlights are and black everywhere else. You'll need to make test exposures for yourself, but for this example let's say the exposure time is two seconds. Process and dry this piece of Kodalith film, which we will refer to as Mask A, the highlights.

Now, having not changed focus or the position of the base board, place a piece of punched, unexposed Kodalith film, emulsion-side up, onto the registration board. Place Mask A, also emulsion-side up, in register, on top. In printing, we would normally pass light through the film base-side first. In the case of making separation masks for a posterization, it is necessary to reverse the image at this stage so that the final result will read properly. Therefore, the Kodalith sandwich is placed onto the registration board emulsion-side up. Increase the exposure just enough to print through the second tonal area to be separated. An exposure time of four seconds would be right for our example. This creates Mask B, the middle gray. Process and dry.

Mask A, which records the white areas, will prevent light from exposing the portion of Mask B that it covers. The thickest densities of the continuous-tone negative, which record the black areas, have not been sufficiently exposed. Therefore, only the middle gray tones will be recorded on Mask B.

The last mask is for the shadows or thickest densities of the negative. It would make very little sense to try to pass light through the maximum densities of the continuous-tone negative, so remove it from the carrier. (Be careful not to bump the registration board or to change anything on the enlarger.) When Masks A and B are together, in register, the clear portions they have in common will correspond to the maximum densities of the continuous-tone image. To create Mask C, the black tones, place a punched, unexposed piece of Kodalith film, emulsion-side up, on the base board. Place Masks A and B in register on top, in that order. Then expose; in this example six seconds is about right. Process and dry. When finished, Mask C will be clear except where Masks A and B overlapped.

Since all these separation masks have been made from a continuous-tone negative, that means they are positives. To recreate the original as a posterization,

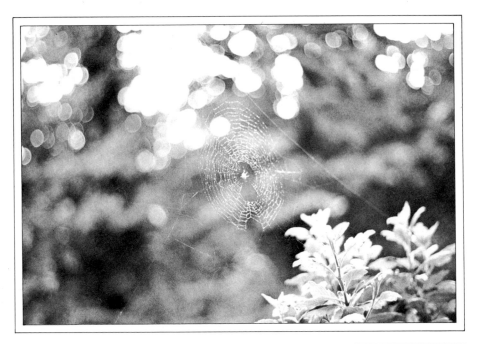

The many different forms in the straight photograph at the top of the page are distracting. They all seem to be on the same geometric plane. By producing a tone line, above, many of the dark and light forms in the background were reduced to only light forms and the plant in the lower right-hand corner became white forms outlined in black. This helped to create a diagonal viewing line from top to bottom and divided the print into separate levels.

we must then contact-print each positive onto another piece of Kodalith to get a negative. Again, the idea is to translate the tones without alteration. This process is quite similar to the first steps of tonal deletion.

Take Mask A, the highlights, and sandwich it, in register, with a piece of unexposed Kodalith, emulsion to emulsion. Through a series of tests, find the proper exposure that will directly translate the tonal areas without increasing or decreasing density. Once you find the best exposure, you should be able to use it as you repeat the procedure for both Masks B and C. You will now use these new negative separation masks to create your four-tone posterization.

PRINTING THE SEPARATIONS

After the negative separation masks, each representing a single density, have been produced, they are exposed in register onto the same piece of photographic printing paper. The finished print will have the same form and shape of the original continuous-tone negative, but not the same tonal range. All tones have been condensed into either white, middle gray, or black in the separations.

The actual posterized print is made by removing the mask for the tonal area you wish to expose; the remaining combination is exposed to light. Then replace the mask in the stack and remove the next one. It is important always to maintain the masks in the proper order. Mask A will be emulsion-side down, closest to the printing paper, which must also be hole-punched. Masks B and C are then placed emulsion-side down on top of Mask A, in that order. For each area you wish to expose, remove the corresponding mask and print through those remaining, still in the proper sequence. The exposure for each mask should be just enough to produce the corresponding gray tone.

In our example, the first exposure will be for the middle gray tone, so we remove Mask B, leaving Masks A and C emulsion-side down, in register with the printing paper. The proper exposure for middle gray will depend on the aperture of the enlarger lens and the printing paper's grade number and surface type. The only way to determine the correct exposure is through test strips. This example will use a five-second exposure time.

The second exposure will be made with Masks A and B together. Mask C, representing the shadows, has been removed. The exposure time must be just enough to create a rich, black tone to the best capability of the printing paper. In this example, ten seconds was sufficient.

Mask A, representing the highlights, is not removed for an exposure. The color of the unexposed printing paper will represent the whites, so the corresponding areas must be protected from light with Mask A.

After the exposures have been made, the printing paper can be processed normally and dried. If there is any problem with registration, check the registration pin alignment. If all checks out, repeat the exposure steps, this time being careful not to bump the enlarger or your base board registration system.

The posterization effect can be produced with more than three separation masks, each representing a different tone of gray. More separations will make the posterization more subtle. However, if you make a separation for every tone present in the continuous-tone negative, you will have only re-created the original gradation and the special effect will be completely destroyed.

BAS-RELIEF

To get an intriguing three-dimensional or outlined effect, try sandwiching a positive and a continuous-tone negative together but out of register. The shapes in the print will be separated by either black

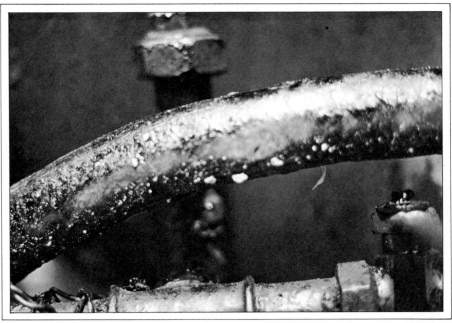

This straight print was made on Agfa Brovira grade 5 paper, an old grading system that Agfa has since changed. Although I saved this paper particularly for very high-contrast situations, any high-grade paper could have been used.

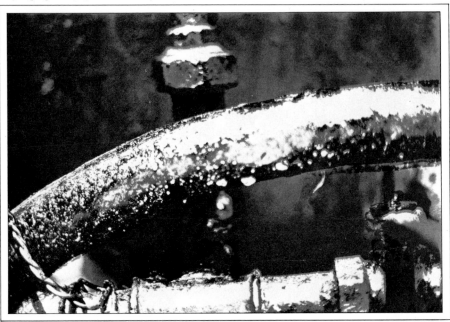

This four-tone posterization was made on Agfa high-grade paper. Because of the elimination of tones and because Kodalith paper has such a sharp cut-off point between blacks and whites, there are more white areas throughout the posterized print than in the original.

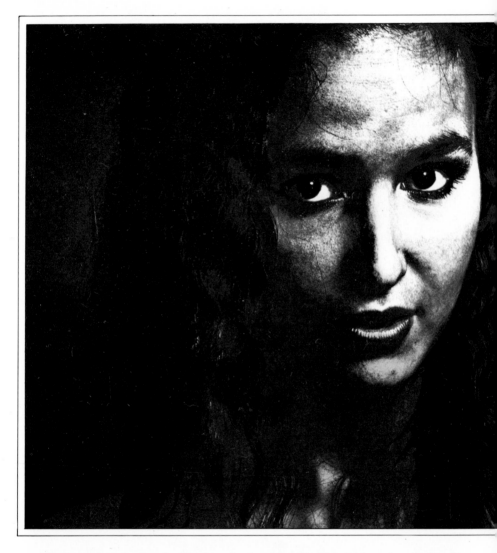

or white lines, thus creating the illusion of a third dimension. Because the result of this sandwich is similar to a bas-relief carved on stone or wood, we refer to it as a bas-relief print. The image in the final print will give the illusion of a raised figure casting a shadow to one side. How much of an illusion depends on how much you displace the negative and positive images in the sandwich.

Normally, if the image is made up of fine detail, a delicate, thin-line bas-relief is preferred. This is done by placing the positive and negative only slightly out of register. Bolder images generally work better with a wider-line bas-relief.

It is easier to produce this effect when working with a larger negative (4 × 5), but the degree of displacement must be greater. It is important, too, that the positive and the negative have a similar density, or else the highly detailed areas will become jumbled. Any picture with sharp focus will work fairly well.

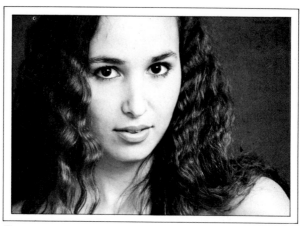

The original print was made on Ilfobrome grade 4 paper, chosen for the mood of its flatter, softer tonal qualities.

Using a five-tone posterization printed on Agfa Brovira grade 4 paper, the overall mood is changed to a more dramatic one. The original print gives a soft feeling. The dark and dramatic posterization gives better emphasis to the center of the subject: her eyes, cheeks, nose, and mouth.

Tonal Deletions

1. Enlarge or contact-print the continuous-tone negative so it fits onto a piece of Kodalith film. Expose the film and develop as explained earlier (page 99). This will give you a high-contrast positive.
2. After the high-contrast positive is dry, contact-print it with a piece of Kodalith film to produce a high-contrast negative. The goal is to translate the tones directly without alteration.
3. From this high-contrast negative make the high-contrast print (containing only black and white tones) by contact-printing it with a piece of regular photographic printing paper. Select the exposure for the high-contrast negative on the basis of what produces a good black tone for that paper.

Tone Line

1. Select a continuous-tone negative that shows a very graphic form.
2. From this continuous-tone negative make a positive Kodalith. If you want the positive Kodalith to be the same size as the negative, simply sandwich the two films, emulsion to emulsion. If the positive Kodalith is to be larger than the negative, project the negative in the enlarger onto the Kodalith as if making a print. Process normally through to dry.
3. Contact-print this positive Kodalith, emulsion to emulsion, with another piece of Kodalith film to produce a negative with the same density. The positive-tone line piece of Kodalith should be retouched with opaque before printing. Pinholes on Kodalith are a common problem. Any pinhole that is seen on the film will produce a black dot on a white field unless retouched now. (Black dots can also later be removed from the print with a bleaching acid.)
4. Carefully align the positive Kodalith with the negative Kodalith, base to base, in register. When properly in register, these two Kodaliths should produce a totally black area. The negative image's clear areas will fill the corresponding positive's dark areas. Look at the sandwich and determine which Kodalith, the negative or the positive, has the largest area of solid black. Place this side of the sandwich against the emulsion of a piece of unexposed Kodalith film, and place the new sandwich into a contact printer.
5. Set the enlarger lens at its widest aperture and adjust the light so that it gives a large area of coverage on the enlarger's base. Set the timer for 45 seconds.
6. Place the contact printer containing the sandwich within the area covered by the light from the enlarger lamp.
7. Because the positive and negative Kodaliths are base to base, a slight gap is created between the actual emulsions of each film. By placing the print frame under the enlarger in a way that allows the light to fall on it at a 45-degree angle, the light will pass through the gaps caused by the thinness of the Kodalith film itself. It then registers as thin lines on the unexposed Kodalith at the bottom of the sandwich. To control the size of the gap, which controls the thickness of the line, try placing pieces of clear acetate in between the positive and negative Kodalith film. This increases the gap size and allows a wider beam of light to reach the bottom Kodalith.
8. Expose the sandwich and process the bottom Kodalith to produce a positive tone line. (Contact-print this result with another piece of unexposed Kodalith to obtain a negative-tone line if desired.) This result is placed in the enlarger, and a standard print is made.

Method 1. Using Continuous-Tone Film

1. In complete darkness, contact-print a 35mm black-and-white continuous-tone negative to another piece of continuous-tone film, emulsion to base. Adjust the exposure to produce a positive with similar contrast but slightly less density than the original negative.
2. Sandwich the original negative, emulsion toward the paper, with the new positive, also emulsion toward the paper, but slightly displace the two. Make a conventional print.

Method 2. Using Kodalith Film

1. Under the light of a 1-A red safelight, enlarge a 35mm continuous-tone negative or contact-print a 4 × 5 continuous-tone negative onto a piece of Kodalith film. Use an exposure that produces equal amounts of both the shadows and the highlights. This produces a high-contrast positive.
2. From this high-contrast positive produce a high-contrast negative with similar tonal qualities.
3. Sandwich the high-contrast negative and positive, slightly displaced, and make a contact-print. Use a higher-grade printing paper than normal.

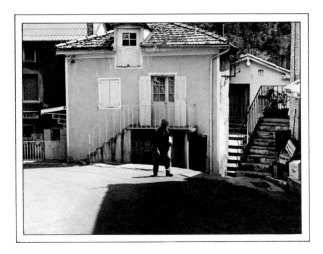

Using Method 2 (Kodalith positive with a Kodalith negative), I was able to give the straight print above a much stronger point of view. The high contrast helped to enhance the harsh lighting of the day I made the photograph.

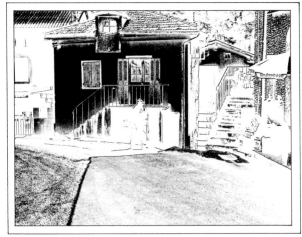

This is a variation of Method 2, still using the same negative original. In this version the density of the Kodalith negative is much greater than the matching positive. Both versions received the same amount of exposure and were contact-printed onto a high-contrast paper.

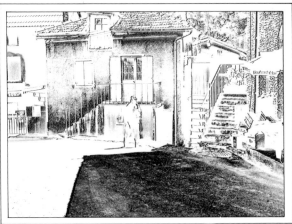

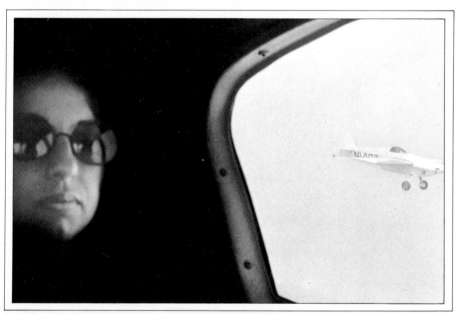

In reality, it is often hard to get a shot like this, because it is not easy to control so many variables. The photographer found it easier to take two separate negatives and incorporate them into one to produce the effect she had in mind. The shot of the face from inside the plane made the window a blank area and allowed a very easy double print to be made. *Photo by Ann Brandeis.*

7

Combination Printing

Many darkroom workers think that the effect of combining elements from different negatives to produce one print brings photography closer to being an art form because the final result (the print) is highly manipulated. In the mid-1800s, when photography was in its infancy and considered a science, not an art, combining two negatives was necessary. Film emulsions then were incapable of recording the wide range of tones that existed in a sunlit situation, particularly landscape shots that included any part of the sky. An average light ratio on a sunny day was too much for the film to handle, and thus two exposures were necessary: one for the ground, one for the sky. These two negatives were then combined in the darkroom to produce one print with good detail in the ground section and good detail in the clouds. This method of manipulating the final print is still popular with some photographers even though film emulsions have been improved and this process is not necessary. Combining two negatives to produce a single print produces an effect all its own and requires much time and concentration to perfect.

SELECTING NEGATIVES

Taking more than one negative and combining them to produce a single print can be done in the camera, in the darkroom, or in both. The important part in any case is the selection of negatives that work together to make a clear final statement. Either select old negatives and piece them together on a light table or shoot a couple of rolls, using a blending mask over the lens. The goal, either way, is to match two negatives that have an area of similar tone; this area will be the blending point. Look for areas with the same material or substance, such as water, grass, or sky. Also look for an uneven line as the cutoff point or for some blurry area, such as tree-tops. It is hard to make a blend seem nonexistent when working with such a sharply defined line as an undisturbed horizon line.

It may be difficult to find a suitable set of negatives from the past to combine. Not just any two negatives can be put together to produce an acceptable print. They should have the same contrast and density. You may find this by chance, but in most cases a new set must be shot while keeping the final print in mind.

To produce a suitable set of "half-negatives" by using a blending mask is quite simple. The blending mask can be made with a series filter holder and a piece of black cardboard cut into a semicircle to fit the holder. Rotate the filter holder, with the cardboard in place of the filter, until you have blocked out the area into which you will print the second negative. It is important to use a large diaphragm opening ($f/4$ on a normal lens is about the smallest opening I use) so that the edge of the black cardboard semicircle is not a sharp, straight line across the negative. This will allow for easier blending of the two negatives in the darkroom. Advance the film to the next frame and

produce another "half-negative," this time rotating the blending filter 180 degrees to mask out the area of the previous negative that has already been exposed. Now you have a set of negatives to be combined and printed together.

The process of blending in-camera can also be used to produce this effect onto a single negative in the camera. It is necessary to have a camera that will allow a double exposure. This in itself can be a problem for alignment. Some other points to consider are that when you double-expose in-camera, the second exposure you make must fit together with the one waiting on your film. In the first method, "half-negatives" can be matched at any time. Also, when working in 35mm, it is often hard to adjust the blending mask so that the edge of the semicircle coincides properly on the same negative. When working with a 4 × 5 camera, the double-exposure method is much easier, because exactly where the blend is to take place can be drawn on the ground glass with a grease pencil. This allows you to replace the dark slide and make a random exposure onto another piece of film, then go back to the "half-negative" and produce the matching exposure at a later time. In this case, it is important to keep very extensive notes concerning exposure of the first "half-negative" and to remember which half of the film was exposed.

PRINTING

After you have obtained your negatives and found the combination you wish to use, there are two methods of printing to choose from: sandwiching the negatives together or blending them one by one on the paper.

Sandwiching two negatives requires a bit of patience and skill. Everything must be lined up properly, because when enlarged, small mistakes on the film will be amplified considerably. For this reason, 35mm film is not the best size to work

with when sandwiching. Handling can become very difficult and time-consuming. Again, it is preferable to work with 4 × 5, although any size 120mm or bigger is fine.

If you prefer to create an invisible blend, I suggest that you use the "half-negatives" made with small f-numbers (f/4). This will give you the largest area of soft focus to use for your blend. On a light table, set up the corresponding negatives so that their overlap creates a density in the intersection that is the same as in the rest of the negative. When they are in place, tape these negatives together with black opaque photo-tape, place into a glass negative carrier, and make your print.

A much simpler method of combining the two negatives is through an enlarger blend, which is exactly what it sounds like. Using the enlarger, you produce a blend of two different negatives, exposed at different times and combined as they are printed on the paper.

Set up the enlarger with your first negative. Enlarge it so that it will fit as you want in the final photograph and make a standard print. Record all the data necessary for reproduction, such as enlarger height, enlarger lens size, lens f-stop, lens height, exposure time, and any dodging and burning information. Before removing the first negative, place a piece of clean white paper on the easel and turn on the enlarger lamp with the lens wide open and with all printing filters removed. This should project the image so that you will be able to sketch it onto the piece of white paper. Draw a line indicating where the negative edge starts to fade and where the enlarger blend will begin to take place.

Now place your second negative in the enlarger and line it up so that it covers the unsketched half of the white paper. When in place, sketch the image and again record the edge of the negative where the blend will take place. The two negatives should overlap a little in the sketch, giv-

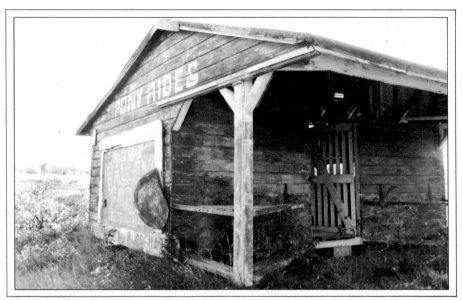

The basis for the final combination print is this shot of a shack. A sky will be placed in the burnt-out area of the negative.

This dramatic sky will be added to the shack to produce an interesting and pleasing landscape.

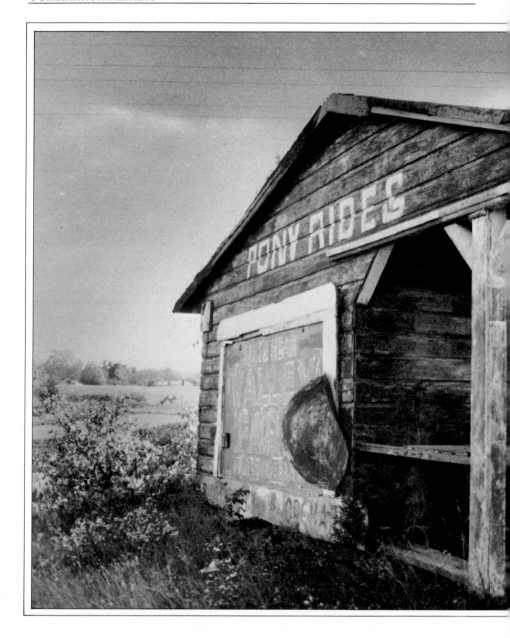

Both negatives were printed on the same grade 4 paper to make the combination easier. The exposure was a bit long to allow more time for burning-in and dodging. First an exposure was established for the shack and a master print made, recording an alignment point for the second negative. Then an exposure was established for the sky and the master sheet returned to the easel. After making sure the alignment was correct, the shack area was protected while the new sky was added.
Photos by Michael Wade Blatt.

A properly exposed negative of a lake shore and islet was combined with a poorly exposed negative of a mountain and sky to create an interesting new picture. The sky was burned in somewhat to balance the dark line at the bottom of the print.

ing you an area to work with for the blend. After this is done, replace the white sketch paper with a printing paper and make a good print, recording all data as you did for the first print, and process normally to check your exposure choice.

After recording all necessary data, take a new piece of photographic printing paper and make an exposure for the second negative still in the enlarger, just as was done for the test. During the exposure, use a piece of cardboard with a straight edge to protect the half of the paper where the first negative will be printed. Move the cardboard continuously so that an obvious line is not created within the space sketched off for the blend area. Do not process this piece of paper yet. If you

need to turn on the white light to replace the negative and make adjustments to the enlarger, make sure you place the printing paper in a light-tight box. Mark the location of the easel and the paper so everything will line up again.

When the enlarger is set for the first negative, replace the paper according to your line-up marks. Expose the other half of the paper, again protecting the exposed half with the piece of cardboard, continuously moving it along the blend line. You must do this for the entire exposure time. When time is up, process the print normally. If the blend is too obvious, repeat the above steps, paying more attention to your movements with the cardboard along the blend line.

Combination Printing

Method 1

1. Choose two negatives of similar contrast and density. A 4 × 5 is an easier size to work with than the 35mm, but anything 120mm or larger is good.
2. Piece the negatives together on a light table, trying to create a density level in the blending area that is similar to the rest of the negative.
3. When satisfied with the sandwich you have created, tape the negatives together with black, opaque phototape.
4. Place the negatives into the carrier of the enlarger and make a standard print.

Method 2

1. Choose two negatives with similar density and contrast. With this method, 35mm negatives will work well because they will be aligned by projecting them in the enlarger.
2. Set up the enlarger for the first negative. Record the enlarger height, lens size, lens aperture, exposure time, and any dodging and burning information. Enlarge the image to the actual size wanted for the final print. Make a standard print of the section

you will use and process normally.
3. Before removing the negative, place a piece of clean white paper on the easel. Turn on the enlarger and open the aperture as wide as necessary to be able to sketch the image from the first negative onto the paper. Be sure to mark the area where the blend will take place.
4. Place the second negative into the enlarger and line it up so the portion you plan on using covers the unsketched portion of the white paper. Be sure to make the two images overlap and sketch the area in between the two negative edges. It will be between these two lines that the blend will take place.
5. Make a properly exposed print from the second negative and record the same information as in step 2. Leave the negative in the enlarger and process the print normally.
6. Compare the prints of the two negatives that will be combined. They should have similar contrast so that they can be printed properly onto the same grade paper. (It would be ideal if exposure times and other enlarger data were the same, but it is not necessary and is unlikely to happen.)
7. Remove the sketch and place a new

The horizon line was used as the blending point in this combination print of a lake and a mountain and sky. Using the horizon is the easiest way to make sure of getting an unobtrusive blend.

piece of printing paper in the easel, which should still be set up for the second negative. While making the exposure, dodge the other half of the paper completely with a large piece of cardboard. Always keep the cardboard moving so it doesn't leave a line between the exposed and unexposed areas. Look at the sketch to approximate the areas.

8. Change negatives and make any adjustments necessary to the enlarger. If you need to turn on the lights, be sure to mark the printing paper and the easel so they will line up again

and place the half-exposed printing paper in a light-tight drawer or box.

9. When all of the adjustments are made, replace the half-exposed piece of paper and line it up. Make your exposure on the unexposed half, this time dodging the exposed half.

10. After exposure is completed, process the printing paper normally. If the two negatives do not line up properly, check the enlarger data you have recorded. If all checks out, repeat the process from step 1, this time paying closer attention to the realignment of the paper for step 9.

8

Montage

An alternative method for creating a photographic image is a montage. This technique requires the combination of two or more different images to make a complete artistic statement. The degree of manipulation is constantly questioned by artists. Some feel the montage should be something that suddenly comes to mind without any manipulation beforehand. You could say, "It just happens." Others go to the extent of figuring out precise camera angles and maintaining exact densities and contrast levels in the negatives that will make the prints used in the montage. As in many forms of artistic expression, it all depends on you.

The physical construction of a montage, though, leaves very little to be questioned. Different pieces from separate images are cut out and placed together in a new composition. These pieces can be either exact shapes that you have cut out with a pair of scissors along the shape's borders or geometric cube pieces that are later pieced together like a mosaic. Both methods allow you to re-create the scene any way you want. Your creativity is limited only by your imagination.

It is usually better to start with a background 16 × 20 or larger. It can be any number of things: wood, cardboard, another photograph, whatever your imagination sees. The larger size allows for easier handling of the small pieces from the different images and seems to make it easier to previsualize the final image. Because the 16 × 20 background image can be rephotographed and reduced to a smaller size after all the various pieces are put in place, little mistakes can become less noticeable to the viewer.

When choosing a photograph for the background, look for one that has open spaces, like a landscape, into which you can place the other images. You may find it interesting to juxtapose your image and background, for example, to place boats on desert sand or a building on water. This is truly the advantage of a montage and the root of the artistic freedom it allows: you can place objects into a setting in which one would not commonly see them, for the sake of artistic composition. Again, your only limitation is your imagination. If you are looking for rules on which to base your ideas, stop. There are none.

When using the geometric cube technique of montage, it's helpful to photocopy your original images before you start cutting. Use these photocopies as work prints and play with the pieces until you achieve the composition that pleases you. Then, working from the copies, use your originals.

First, cover the back of your original images with rubber cement. Because rubber cement adheres only to itself, you can handle it freely as long as you avoid another rubber-cemented surface. After the cement has dried, it will leave a slightly tacky surface that will hold the print to a noncemented surface but still allow you to lift it up and move it.

Place your image, face up, on a piece of cardboard that can be used for cutting

The two images from page 126 were combined to make this mosaic-style montage. Each of the original photos was cut up into quarter-inch squares and then arranged on a background.

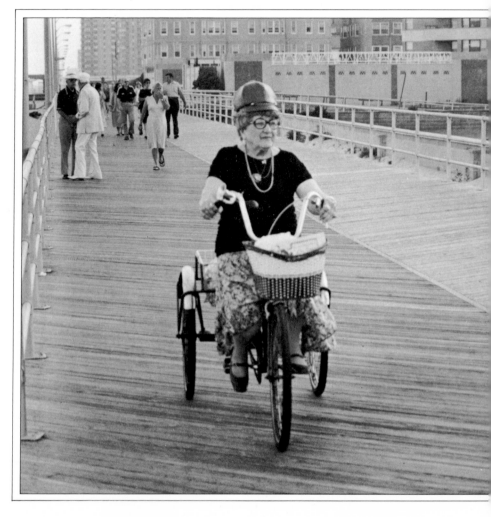

with a razor knife. Tape just the very edge of the photograph all the way around and measure off each side evenly. Draw lines across the photograph with a soft lead pencil (F or #2), forming a grid. These measurements should correspond to your work print if it was photocopied at a 1:1 ratio. Then number each space along both the horizontal and the vertical sides of the print and work print.

Now translate the measurements and grid system onto a piece of clean mount board. Center it evenly, because this will soon become the final image. You can also take pieces of masking tape and lightly fix them to the vertical and horizontal sides of the grid so you can number the rows and columns. After checking all measurements just to be sure no mistakes were made, cover the grid area with a coat of rubber cement and let dry.

While the mount board is drying, cut your original photograph along the lines you have drawn. When the mount board is dry, place the pieces of your photograph into the corresponding space. When this is done, use a rubber cement pickup to remove all leftover cement.

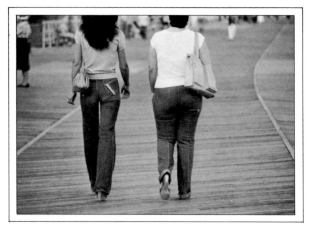

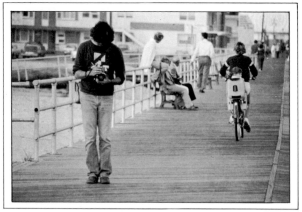

I took these pictures of tourists on the boardwalk of Atlantic City, New Jersey, with a montage in mind. I wanted to juxtapose the images of a crowd of tourists and an open landscape.

I used this shot of the wide-open spaces of Arizona as the base for the montage. Each image from the Atlantic City pictures was cut out first with scissors, and then carefully contoured with a razor knife. The edges of each piece were then filed with an emery board and darkened with a soft lead pencil. After placing each onto the background of a landscape in Arizona, using rubber cement, shadows were added using retouching dyes (overleaf). Notice how the people are sized and placed to give a sense of perspective.

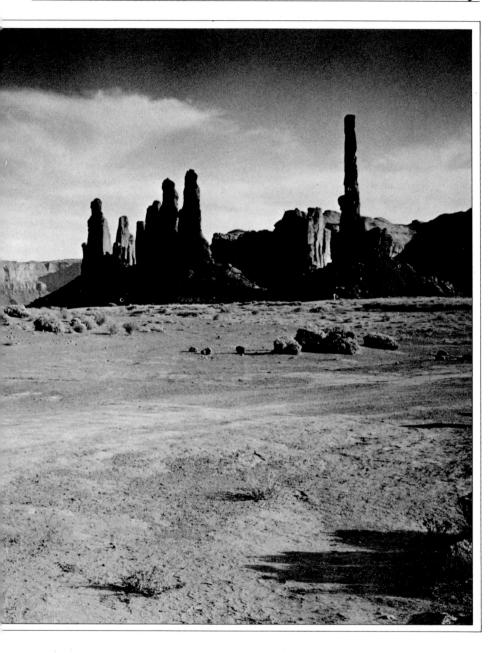

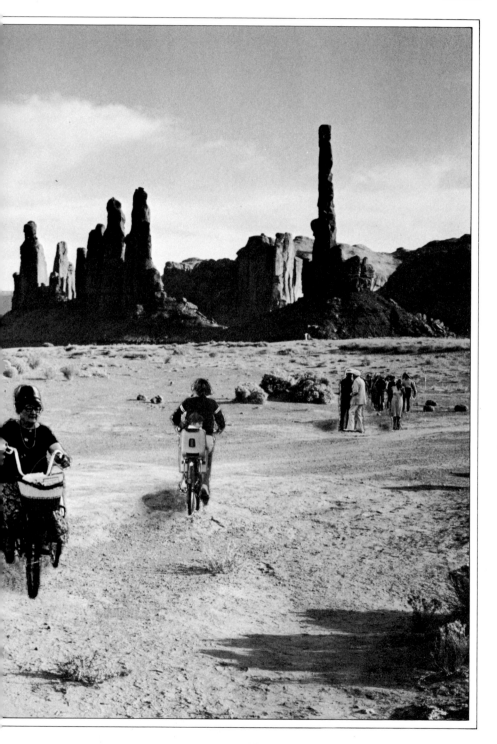

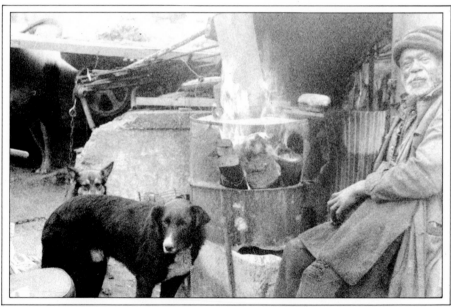

The grain in this photograph is due in part to the mist that existed when the picture was taken; it was also increased by use of an undiluted developer. The tones are purposely low to help increase the impact of the mood. *Photo by Ann Brandeis.*

When this print (overleaf) was toned in selenium toner the shadow and darker density areas were intensified. If done only for the effect of permanance, there would be no sign of color. The print was left in the toner for approximately six minutes. Notice that the print has an overall purple cast. Dilution of the toner was nine parts water to one part selenium toner, at a temperature of 68°F.

9

Toning

Toning, a chemical manipulation of the photographic emulsion, gives the black-and-white print a range of tones not normally characteristic of photographic paper. These tonal ranges are available in a number of colors, and some serve two purposes: both to add color and to give permanence. The extra dimension added by toning can be achieved in three different ways.

The first is simply the choice of a black-and-white printing paper with an innate tone that could vary over a range of browns, blues, or blacks (see Chapter 3). The developer that you choose, as well as its dilution, age, and temperature, will determine which tone you will get. The color tones obtained by this method are very subtle, with variations ranging from cold blue to warm brown tones. The combination of Portriga-Rapid paper with Kodak Selectol developer produces a warm brown tone. On the other hand, Portriga-Rapid developed in Kodak Dektol will produce warm black images. Predicting the different results that various combinations of printing paper and developer will produce can be done only after a great deal of experimentation with your materials.

The second and third methods use chemical toners that will only color areas on the processed print where the metallic silver still exists. The tonal qualities, therefore, will greatly depend on the original print, and it will sometimes be necessary to alter the exposure and contrast of your original image to obtain a good-quality toned print. There is a wide variety of ready-to-use toners to choose from. It is important to check the emulsion of your printing paper and the toner you wish to use for compatibility. Not all photographic papers will combine well with each chemical toner. The chart on page 140 gives some guidelines for selecting papers and toners. Data on various combinations of paper and toner are hard to find. A good source of information on Kodak products (paper and toner combinations) is the J-1 Kodak Professional Data Book, *Processing Chemicals and Formulas for Black-and-White Photography.* For information on other brands' products, try calling the local retailer or representative.

The purpose of the second chemical toning group is not only to add color but to produce an archival print as well. Metal-replacement toners, such as a selenium or a gold toner, work directly on the silver in the emulsion by replacing it with inorganic salts. The image-forming silver of an untoned photograph is susceptible to pollutants in the atmosphere.

Just as silverware and silver jewelry tarnish over a period of time, so will the silver in a photograph. Metal-replacement toners coat the silver emulsion with a more stable, less reactive metal, thus retarding tarnish.

Gold compounds are quite expensive and often produce little visible effect. Selenium compounds, however, are very common protective toners because of their additional advantage of slightly in-

G = Good
VG = Very good
NR = Not recommended
N = Normal

Toners	± Exp.	± Dev.	Developer	Color	Ilfobrom	Ilford Galerie	Brovira	Portriga Rapid	Ektalure	Kodabromide II RC	Ektamatic SC	Medalist	Panalure	Panalure Portrait	Polycontrast & Polycontrast Rapid	Polycontrast Rapid RC & Rapid Type II RC	Azo
*Edwal Blue	N	+	Selectol 1:1	Blue	G	VG		G	G		NR				G	NR	NR
	N	+	D-72 1:2		VG	G	VG				G	G	G	G	G	NR	G
Iron Blue	−	N	Selectol 1:1	Blue-Green	G	G		G	G		NR			G	G	NR	NR
	−	N	D-72 1:2	Dark Blue	VG	VG	G				G	G	G	G	G	G	NR
Kodak Blue	N	N	Selectol 1:1	Light Blue		G		G	G	VG	G	G	G	G	G	NR	NR
	N	N	D-72 1:2				G		G	VG	G	G	G	G	G	NR	G
Kodak Brown	N	+	Selectol 1:1	Warm Brown		G	G	VG	G	VG	VG	VG	VG	G	VG	NR	NR
	N	+	D-72 1:2						G	VG	G	G	VG	G	VG	NR	NR
Kodak Polytoner	N	N	Selectol 1:1	Light Pink to Red Brown		G				VG	NR	G	VG	G	VG	NR	NR
	N	N	D-72 1:2							G	NR	G	G	G	G	NR	NR
Kodak Rapid Selenium Toner	−	N	Selectol 1:1	Purple-Red Brown	G	G	G	VG	VG	G	G	G	G	VG	G	NR	VG
	−	N	D-72 1:2	Cold Brown Faint Blue	VG	G		G	VG	G	G	G	G	VG	G	NR	NR
Kodak Sepia	+	+	Selectol 1:1	Yellow Brown	G	G		VG	G	VG	VG	VG	VG	G	VG	G	NR
	+	+	D-72 1:2		G	G	G		G	VG	VG	G	VG	G	VG	G	NR

*Edwal Toner is also available in red, green & yellow colors.

creasing the tonal range of the print; more in the shadows, less in the highlights. The color change produced by selenium toners depends greatly upon the dilution used. The higher the concentration, the more noticeable the range of color will be while still maintaining its effect on the photograph's contrast and permanence.

The third method of adding color to a black-and-white print is by using mordanted dye toners, which contain a dye base that affixes to the silver in the emulsion by way of a catalyst such as potassium ferricyanide. These dyes are less stable and therefore are not as effective for giving a print permanence. Mordants do allow certain dyes to combine with the silver in the emulsion to obtain a much broader range of colors, but often the paper base will retain traces of the dye, even after thorough washing. This makes them less stable when combined with the effects of long exposure to light.

PRINT PREPARATION FOR TONING

In preparing a black-and-white print for chemical toning, you should make several tests with the paper and developer to see whether the combination will produce good results with the toner you have selected. There may be a need for an adjustment in either the printing or the develop-

ing time, depending on the desired result. Kodak Rapid Selenium Toner usually intensifies the print image, as do iron-blue toners that have ferric ammonium citrate in them. When using these, less exposure would probably produce a much more desirable result. Sepia toners, on the other hand, tend to reduce the print image somewhat and would therefore work better with a darker print.

After deciding which combination (paper/developer) works best, make your print according to the data you have accumulated. After development, place the prints in a standard stop-bath solution for 10 seconds with constant agitation.

Fixing your prints properly is especially important when toning. All silver halide compounds must be removed or staining will result when you apply the chemical toners. After fixing for at least five minutes, rinse the print in running water for about three minutes. The use of Perma Wash or any other washing aid after the water wash is most helpful. Agitate the print for five minutes, then follow with 10 minutes of running-water wash. Your prints should now be free of residual silver compounds; if you're in a hurry, they could go into the toner at this point. However, for the very best results, use a hypo eliminator such as Kodak Hypo Eliminator HE-1, which should be mixed immediately before use. This will help to avoid any problems, such as spotting, later in the toning process.

If you want to tone finished prints (those that have been fixed, washed, and cleared), it is important to check the thoroughness of your wash first. The presence of residual fixer will lead to discoloration. Use the silver test solution described below; if you see any discoloration, the print needs further washing.

SELENIUM TONER

Selenium toner is meant for permanence, but it will also add color to the print. This toner gives a reddish-brown hue to neutral and warm-tone papers; cold-tone papers turn faintly blue in the deep shadows. The advantages of selenium toner over gold are that it is less expensive, it is sold in liquid form, and it is simple to prepare and use. It stores easily and lasts longer on the shelf.

The recommended dilution and toning time is printed on the bottle and refers to the coloring effect. More dilution will produce a more subtle change in color, but there will still be enough selenium to protect the silver in the print. Always wear gloves and *never* use selenium toner undiluted. Always use a separate tray for selenium toning, and don't use the tray for anything else. Be sure to clean all surfaces thoroughly and to check the floor for spots. The toner has a pinkish color when dry and will stain many surfaces permanently if allowed to dry on them.

Two ways to use selenium toner are outlined below.

Method 2 differs from Method 1 in that distilled water is used to dilute the toner instead of hypo-clearing agent. Method 2 is used for toning finished prints: those that are fully fixed, cleared, treated with hypo eliminator, and fully washed.

SEPIA TONER

Prints to be sepia-toned must be thoroughly fixed and washed. The use of a hypo neutralizing bath is very important, as any traces of fixer in the paper will cause uneven toning. The prints will also need an increased exposure of about 10 to 15 percent and/or increased development by about 50 percent or more. Test to be sure your paper is compatible with the toner. Some paper/toner combinations produce unpleasant changes in tone.

IRON-BLUE TONER

Iron-blue toner will produce a brilliant blue tone. The tones will depend on the

original print tones; if the original print is light, then the blue tones will be light as well. Prints tend to be intensified by iron-blue toners, so a slightly underexposed print should be made.

SPLIT TONING

In split toning, a whole new range of tones that do not invade the highlight areas is created. This gives the print a three-dimensional feeling instead of the two dimensions of regular toning. The split in tones is due mostly to the temperature of the toner. Generally, use the same

procedure as for normally archival-toning a print in selenium toner. The difference is that the print remains in the toner for a longer time at a higher temperature.

Silver-chloride contact papers, such as Kodak Azo contact paper, are better for split toning than chlorobromide enlarging papers because selenium toner has little visible effect on the enlarging papers. It's easiest to work with a larger negative (4 × 5 or larger) and make a contact print when working with Azo paper; otherwise, the enlarging time must be as long as six to eight minutes because of the Azo paper's slow speed.

Kodak Hypo Eliminator HE-1

water	500 ml
hydrogen peroxide	125 ml
ammonia solution (1 part	
28% ammonia to 9 parts water)	100 ml

1. Soak prints for 5 minutes in running water.
2. Soak prints in HE-1 for 6 minutes at 20°C (68°F).
3. Wash for 10 minutes in running water at 20°C. Dry as usual.

Each one quart yields 12 8 × 10 prints or 12 rolls 120 or 35mm film.

Residual Fixer Test:
Silver Test Solution ST-1

1. Prepare a stock solution by adding 2 g sodium sulfide (anhydrous) to 125 ml water.
2. Dilute the stock solution, 1 part stock to 9 parts water.
3. Take 1 drop of working solution ST-1 and place it on the white edge of a washed print.
4. After 3 minutes lightly dry spot with the touch of a clean paper towel. Examine the print under a good light. If there is any discoloration of the print in the spot where the ST-1 was placed, the print needs more washing.

Selenium Toner Method 1

Method 1 is for fully fixed but not washed prints.

1. Mix 1 part Kodak Rapid Selenium Toner to 9 to 12 parts hypo-clearing agent at 20°C (68°F).
2. Take a print from the second fixing tray, drain, and place in toner. Do not rinse first or yellowish blotches will appear where the rinse didn't remove all the fixer. If the print is totally saturated with fixer, there are no gaps where stains could develop.
3. Agitate constantly for 2 to 6 minutes. There should always be fresh toner on the print; otherwise, it may tone unevenly.
4. There are a number of variables on how long a print should stay in the toner. The type of paper and the degree of toner change you want are the two most important. The solution will respond faster as more prints are put through. For a permanent print, as soon as there is no more noticeable change to the print, it is safe to assume that sufficient time has passed for longevity.
5. After removing prints from toner, place them in a working solution of hypo-clearing agent. Agitate for 5 minutes.
6. Wash as usual.

Without the toner this print seems a little boring. There seems to be too much of a modern quality to the print; it doesn't coincide with the expectation of a stone sculpture of this type. This print was made on a cold-tone paper and developed in a cold-tone developer.

Selenium Toner Method 2

1. Make sure that the print is free from fixer residue by using the residual fixer test described earlier.
2. Dilute the toner, using 1 part Kodak Rapid Selenium Toner with 9 to 12 parts distilled water.
3. Take a print from the second fixing tray, drain slightly, and place in toning bath. Since the print is not fixer-laden, it does not have to be agitated continuously, but intermittent agitation is helpful in keeping fresh toner on the print surface.
4. Keep an untoned print nearby so you can compare it to the one in the toner. This will help you to see how far the toner has gone. The toner will work slowly at first but will increase in speed and intensity as you go along. Pull the print just before it reaches the degree of toning you desire; the momentum the toning process has built up will complete the process even after removal.
5. Place the print in a tray of working solution hypo-clearing agent. Agitate for 5 minutes and wash. Kodak Rapid Selenium Toner contains fixer, so clear and wash as you would for newly fixed prints.

Redevelopment Sepia Toner
DUPONT 4a-T

When using sepia toner, never use metal tanks, trays, or stirrers. Always use plastic or hard rubber.

Bleaching solution:

water not warmer than 27°C (80°F)	750.0 ml
potassium ferricyanide	25.0 g
potassium bromide	27.4 g
ammonium hydroxide (28%)	2.0 ml
water to make	1.0 lt

Use the bleaching solution undiluted. Bleach thoroughly fixed and washed prints until image is only faintly visible; this should take about 1 minute. Wash until no trace of yellow stain remains, then redevelop in redeveloping solution until desired tone is obtained.

Redeveloping stock solution:

sodium sulfide	50.0 g
water	1.0 g

Dilute the stock solution to 1 part stock with 8 parts water. After redevelopment, wash prints thoroughly and dry as usual.

Iron-Blue Toner Gaf 241

distilled water at 53°C (130°F)	500.0 ml
ferric ammonium citrate	8.0 g
potassium ferricyanide	8.0 g
acetic acid (28%)	265.0 ml
distilled water to make	1.0 lt

Use undiluted. Prints should be underexposed by about 15 percent to obtain a good toned print.

1. Test for any traces of fixer by using the residual fixer test.
2. Place prints in clean water bath for about 3 minutes.
3. Place prints in undiluted toner and agitate intermittently.
4. Pull print from toner just before desired tones are achieved.
5. Fix prints in a nonhardening hypo bath for about 5 minutes at 20°C (68°F). (Kodak Fixing Bath F-24 is a good nonhardening hypobath.) Prints will appear greenish at first but will wash to a clear blue in water bath.
6. Wash prints for 10 minutes in a tray of water wash that has been acidified slightly. (Take 28 percent acetic acid and dilute with water at 1 part acid to 15 parts water.) Alkaline water can weaken the intensity of the blue tones.

Split Toning with Selenium Toner

Toner-clearing bath:

selenium toner	70 ml
Perma Wash	30 ml
Kodalk or sodium metaborate	20 g
water	1 lt

If stains appear during toning, separate into 2 baths of five minutes each.

Bath 1. Perma Wash and Kodalk in 1 lt water.

With the use of a sepia toner, an antique appearance is created that helps to increase the mood of the image. This print was toned in sepia toner for about two minutes, one minute in the bleach and one minute in the toner, with a water wash of 30 seconds in between.

The feeling I was after in the inset photo is the emptiness of the chairs during an off-season period. The composition is meant to produce a bit of tension to help intensify the emptiness. By using the iron blue toner, I was able to increase the cold, empty feeling. The print was left in the blue toner for about three minutes and washed for about ten. If washed longer, the highlights would have come cleaner, which is useful in some instances. Iron blue toner will not affect the highlight areas if washed for a long time.

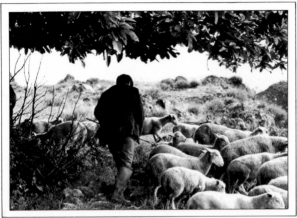

This print was developed in a warm tone-developer (Selectol), and printed on a warm-tone paper (Agfa Protriga Rapid). The effect was a nice warm feeling, but not enough for my liking.

Bath 2. selenium toner with 1 lt water.

1. Develop print in Kodak Selectol Developer diluted 1:1 at 24°C (75°F). Temperature control is important; if the developer goes above or below 24°C, a brownish tone will appear all over the print and the split effect will not occur when you go on to the toner.
2. Wash normally in a stop bath of 28 percent acetic acid at 24°C.
3. Fix (first fixer bath) for 5 minutes at 24°C.
4. Let prints sit in tray of water at 24°C until ready to refix and tone. Change water frequently or stains will appear during toning.
5. Fix (second fixer bath) for 4 minutes at 24°C.
6. Place print in the toner-clearing bath at 24°C for 4 minutes with constant agitation.

If you agitate by hand without tongs, use a pair of good vinyl gloves. Selenium, like mercury, is a poison that is absorbed through the skin. Good ventilation is also important.

7. Place print into a wash for at least 25 minutes at 24°C. The print may be returned to the toner if needed.
8. Let prints air-dry after squeegeeing. Do not heat-dry.

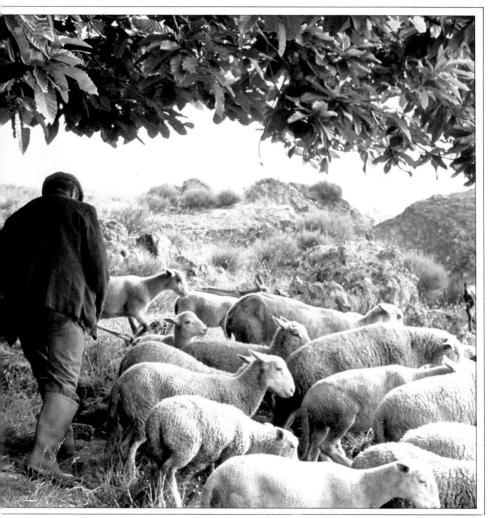

The same sepia toner as used on the stone sculpture was used to increase the warm feeling that was begun with the warm paper and developer. The tones are noticeably reduced by the sepia toner, so now there is detail in the back of the shepherd's jacket and in the shadow areas of the sheep.

I found these trucks above in a situation where the difference between the shadows and the highlights was perfect for a split in toning. The print was made on Kodak AZO paper and developed in selectol developer, diluted 1:1.

The picture above right is the split-toned print of the trucks. After mixing the chemistry I constantly checked the temperature to be sure it was at 24°C. The selenium in the bath was responsible for the slight intensification of the shadows, but the highlights were not as strongly affected as would normally have happened with straight selenium toning.

The picture below right is an example of what happens when the temperature is not at 24°C. The highlights have a noticeable amount of purple from the selenium toner.

An attractive shot by itself, this reticulated print was used as the base for the hand-colored photo overleaf.

10

Hand-Coloring

Hand-coloring has been around since Victorian times. It is a very subtle and charming effect that has a quality all its own, one that cannot be achieved with today's color printing processes. During the 1930s, it was very popular to hand-color portraits and post cards. Even today, some portrait studios take pride in offering hand-colored prints because of their distinguished look.

Today, as earlier, many of the advantages still hold true. The biggest plus for the creative photographer is that objects can be made any color you choose. Because the colors are transparent, the original tones and details of the print show.

Another advantage is that hand-colored prints are as archival as the original uncolored print. That is to say, if you use a hypo-clearing agent, wash and dry the print properly, and then color it, the print will still last forever. Color prints made from color negative film are very unstable and tend to begin fading after about seven years. At first it is not very noticeable because it happens so gradually, but after 10 to 15 years, depending on the storage of the print, the colors are noticeably faded. Hand-coloring, therefore, is one of the only ways to produce an archival color print.

Overall, hand-coloring is less expensive than color processes. A beginning Marshall's Oil Color set costs the equivalent of processing one roll of color negative film. From that set you should be able to hand-color approximately 75 to 100 8 × 10 prints.

When choosing a print for hand-coloring, pick one that has a full range of tones but not too much black area. It is almost impossible to see the color when it is placed on a dark area. Whether you use color dyes, watercolors, pencils, or oils, the coloring agent is transparent and is suspended in the gelatin around the silver crystals. The lighter areas of the print will allow the color to be seen.

So that the colors will sink into the paper, make the print using a matte or semi-matte paper. If you use a glossy paper, oil paints will not be absorbed; this will cause streaking and unevenness. The result will be a print that looks painted *on,* not one that is painted *in* and blended with the emulsion. Watercolors on glossy paper will bead up, and pencils will scratch the surface.

To get a feel for the materials and how they affect the print, it is best to work small, using a print that is no larger than 8 × 10. Many experts prefer the 5 × 7 format or even smaller.

One of the principal reasons for using hand-coloring is to call attention to a particular area of the photograph. The use of a splash of color helps to draw the viewer's eye right to the center of attention. Hand-coloring a specific area can also be used to help create a visual balance. Placing a touch of red color, for example, against a larger field of gray tones or blacks could help maintain a visually balanced composition.

Hand-coloring can also help to separate different elements in the photograph.

This print is a combination of the reticulated print on page 152 and hand-coloring with Design brand art markers. I chose to use the regular nib markers to create a very flowing stroke. Although it may seem as though the photograph was done in seconds, it required almost three hours and five tries before this one was suitable. Each stroke had to be placed just right and the right color combinations had to be found.

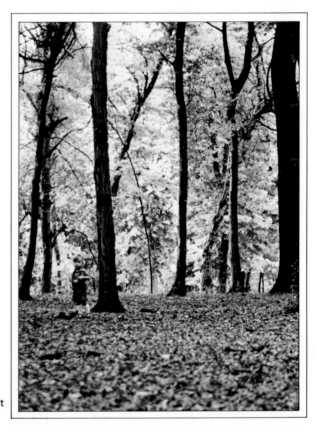

The little boy in this straight print is barely noticeable. I decided to hand-color the print to bring him out.

Sometimes it seems that a certain amount of light, unsaturated color is needed in a picture to enhance it. This does not mean that a flat, dull photograph can be turned into a lively, contrasty one. The tonal range and details of the original print will still come through.

In some photos, there is a need to accent a particular characteristic of the subject. The type of hand-coloring material you use, along with the stroke or application style you incorporate, could be just the thing. For example, the boards on the side of a weathered old barn have a roughness that could be enhanced by the use of markers and a freely applied hand stroke.

Another effect that hand-coloring can achieve is the addition of another dimension. Overall toning of the subject with just one color can often be very striking. It's quicker and easier to do than chemical toning and a lot less messy. The nude on page 163 was toned with undiluted instant coffee. The light, yellowish cream color clearly separates the body from the dark background.

Some photographs are better for hand-coloring than others, depending on the effect you want. Good candidates for hand-coloring are people photographs. They offer a simple image that stands out from the surroundings distinctly when hand-colored. Although often better than landscapes, which tend to look like studies in watercolors and frequently lack the impact of a figure, people pictures are not necessarily easier. One of the hardest things to do in hand-coloring is to obtain a good flesh tone. Often the premixed

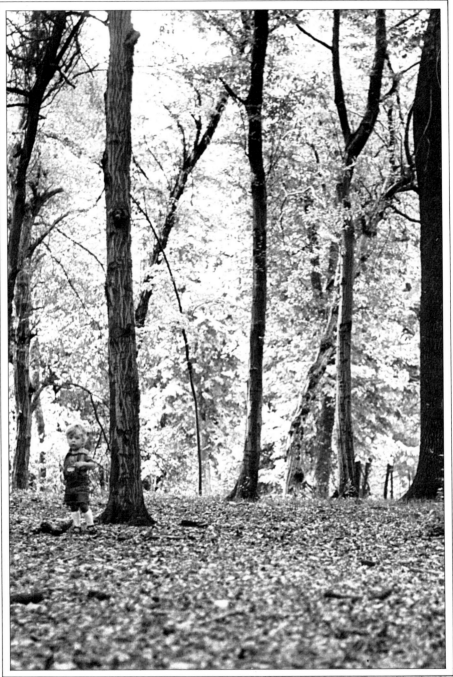

The print was handcolored with Peerless brand watercolors to call attention specifically to the boy without cropping the print. Due to his size in relation to the rest of the photograph, a subtle touch of color achieves the desired effect.

At first glance, I felt this photograph (above) needed some color to help separate the vendor from his products. After coloring him with Peerless water colors (above right), I felt the photograph needed still more color. I continued to color the fruit and vegetables, using colors that would help give the picture more of a dimensional quality (below right). I used black instant coffee to finish the background and empty crates in an off-white color. Large areas were colored with a cotton swab.

colors marked FLESH TONE are too orange or pink to look real. It is better to try combinations of the flesh tone mixed with a little brown, yellow, or white, depending on the desired result.

The method used to apply the colors has a great deal to do with the final effect. Many apply the color with cotton swabs, either purchased or homemade. By making your own swabs, you can create them in different sizes for the different areas of the print. All you need is some toothpicks and pieces of cotton wool. Wet the end of the toothpick and wind the cotton tightly around the tip. Be sure to cover the pointed part of the toothpick; otherwise, you will scratch the surface of the print.

Some photographers also use brushes for hand-coloring. If you prefer this technique, be sure to have different-size brushes on hand for working both on fine, detailed areas and on large areas. Use the best-quality brush you can get. Grumbacher makes brushes both for oil paints and watercolors. Their spotting brushes of the 00 and 000 sizes are very good for fine details. Round sable brushes, sizes 2 through 8, will be necessary for the larger areas. When working with oil colors, use a brush that will hold them cleanly and evenly. For oils, a selection of brushes in sizes 1 through 10 are needed. Because buying a number of different types of brushes can get expensive, homemade cotton swabs are often the best deal.

When using oil colors, remember that the warmer colors—yellows, oranges, and reds—tend to be stronger; the cool colors—blues and greens—tend to be less noticeable. You may therefore wish to

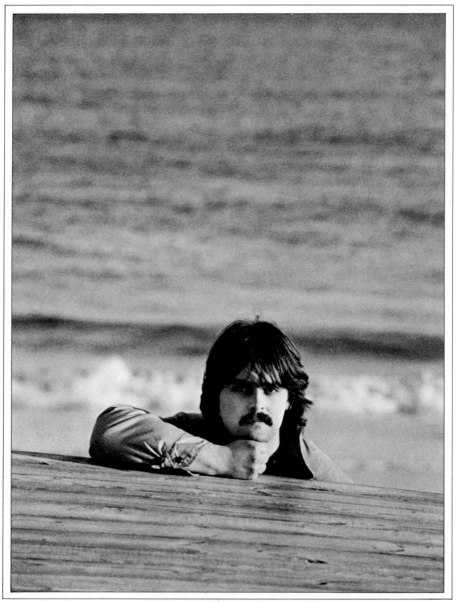

The uncolored version of my portrait of artist/photographer Joseph Heppt is nice, but it seems to lack something. The tones seemed too equal, but a higher contrast paper made it too harsh. There was a need to emphasize his presence in the print.

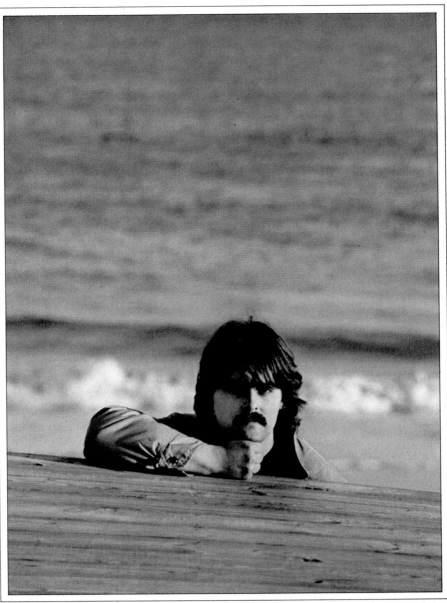

By using soft colors and mixing tones, I was able to produce more depth and more attention to Joe. I felt softer colors would be more subtle in helping the image attract attention, yet still keep the actual quality of sunset lighting. Marshall oil paints were the proper texture and quality to do the job. I applied them with cotton swabs, one color at a time, using the darker colors last to avoid run-over into the light areas, which is difficult to remove.

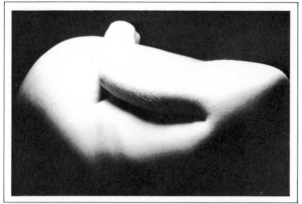

The subtle dimension I wanted could not be obtained by the use of innate colored papers or chemical toners. Instant coffee and a cotton swab was the only way. This coloring really separates the original (above) from the final result (right).

either mix more P.M. solution, which gives oils a lighter tint, with the warmer colors, or just add less P.M. solution to the cool colors. In either case, when using the P.M. solution, be sure to first place the solution onto a separate piece of cotton wool and then touch your cotton swab to it. This prevents you from getting too much solution into the oil colors at one time. Use a separate tray for mixing each color.

Apply oil colors in a circular motion. Start with the largest area first and do the small details last. Smooth down the oils with pieces of clean cotton wool until the surface is evenly covered and the color shade is correct. Marlene solution is used to clean paint from areas you don't want colored. When the print is finished, let it sit for a few hours. If you then decide that you are not satisfied with the results, just clean off the entire print with Marlene solution and wipe it dry. You can start coloring again after about 15 minutes.

When working with Peerless watercolors, use an extra tray for mixing. If you are unhappy with a particular tone, wash the print in running water immediately. Most of the color will come out, but often not well enough to color over. It will depend on how diluted the original color was. Keep in mind that if you have colored another part of the print, that color will be affected by washing as well.

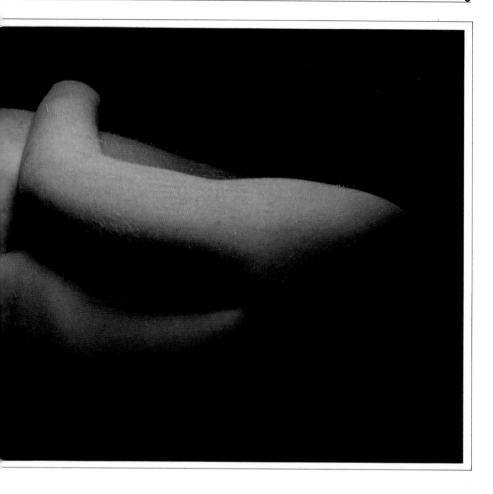

This smoky sky (overleaf) is an example of hand coloring with pencils. The overall tone in the sky gives it a quality close to the actual effect created by the sunset. It also helps to separate the smoke from the other similar tones of gray in the sky. After applying the color with the pencil, a cotton ball with a little P.M.S. (Prepared Medium Solution, similar to turpentine) was used to even out the pencil strokes.
Photo by Ann Brandeis.

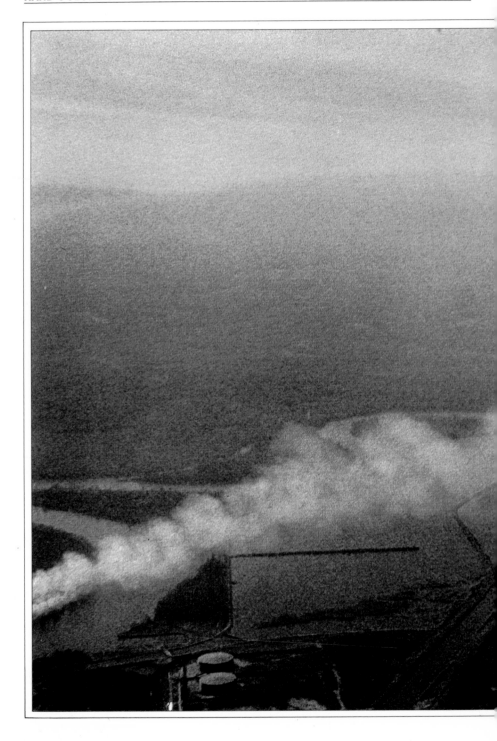

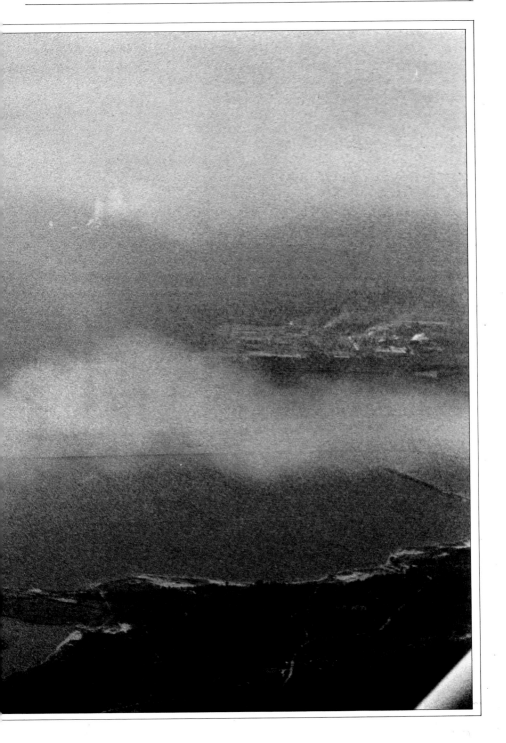

Appendix

Figuring Solution Dilutions

1. At point M, place the percentage of whatever solution you wish to dilute to some lesser concentration. (In this example, 88% acetic acid will be diluted to 28%.)
2. At point N place the percentage of the solution you will use to make the dilution. This is usually water, which has a percentage of 0.
3. At point S place the percentage strength that you want to get in the final solution. (15% in this example.)
4. Subtract S (15%) from M (88%); place this result at F (73%).
5. Subtract N (0) from S (15); place this result at E (15).
6. Mix E (15) parts of M (88) with F (73) parts of N (0). The result is a solution of S (15%) strength.

Glossary

Aberration. A fault in a lens causing a distorted image. Modern lenses contain few aberrations. The most common kinds of aberrations are spherical, chromatic, coma, and astigmatic.

Accelerator. A chemical found in developers, usually sodium carbonate or borax, used to speed up development.

Acetic acid. An acid used in stop baths and acid fixers. It is usually used in diluted form.

Acid fixer. A fixer containing an acid, generally acetic acid.

Acid hardening fixer. An acid fixer containing a hardening agent, usually alum.

Acutance. An objective measurement of image sharpness, based on how well an edge is recorded in the photograph. An image with high acutance would appear sharper and more detailed than the same image with low acutance.

Additive color. Color produced by light in the primary colors blue, green, and red, either singly or in combination. Combining all three primary colors produces white light. Additive color is the principle behind color television.

Agitation. The technique of ensuring even processing by moving the film or paper within the processing solution, or stirring the solution itself.

Alum. A chemical often used in fixers as a hardening agent.

Angle of incidence. The angle at which light strikes a surface.

Angle of reflectance. After light strikes a surface, the angle at which it is reflected.

Angle of view. The widest angle of light taken in by a lens. On any lens, the angle of view is widest when focused at infinity; long lenses have narrower angles of view than shorter lenses.

Anti-halation layer. A thin layer found in film, designed to prevent light striking the film base from reflecting back into the emulsion layers and causing halation.

Aperture. The part of a lens that admits light, the aperture is a circular, adjustable opening.

Archival processing. A method of processing black-and-white film and prints to ensure that they will not deteriorate over time.

ASA. American Standards Association. The sensitivity of a film to light, or its speed, is measured by the ASA standard.

Autowinder. A motorized unit attached to an SLR camera to automatically advance the film and cock the shutter.

Available light. The existing light on the subject, whatever the source may be. This term is often used to describe a low-light.

Back lighting. Light directed toward the camera from behind the subject.

Barn doors. Flaps that attach to the rim of a photo light and can be adjusted to control the amount and direction of light.

Baseboard. The board on which an enlarger stands; any board used as a base for photographic paper.

Bas-relief. A photograph with a three-dimensional effect, created by sandwiching a negative and positive together slightly out of register and then printing the sandwich.

Beam splitter. A clear circle of glass used to simultaneously transmit and reflect a beam of light.

Bellows. A folding chamber, generally of light-tight cloth, between the lens and body of a camera, used to adjust the distance or angle between the film plane and the lens.

Bleach. A chemical bath that reacts with the black silver formed by the developer, either by dissolving it or converting it back to silver salts.

Blocked up. An overexposed or under-developed area of negative that prints as a light, undetailed area.

Bounce light. Light from an artificial source that is reflected onto the subject to give a diffused effect.

Bracketing. Making a series of exposures of the same subject, varying the exposure in increments around the estimated correct exposure.

Brightness. A subjective, comparative measurement of luminance.

Brightness range. The difference in brightness between the darkest and lightest areas of a scene or image.

Burning-in. The technique of giving additional exposure to selected parts of an image during printing.

Bromide paper. A type of black-and-white printing paper containing silver bromide in the emulsion and giving a blue-black image color.

Candela. The internationally recognized standard unit of measurement of luminous intensity.

CC filters. Color correcting filters, available in assorted colors and with densities ranging from .05 to .50.

Characteristic curve. A graph indicating the relationship between exposure and density for a photographic film.

Chroma. In the Munsell system of color classification, the saturation (purity) of a color.

Circle of confusion. A ray of light focused on the film plane registers on the film as a point. If the ray is not in focus, it registers as a tiny disk, or circle of confusion. If the circle of confusion is small enough, it will be indistinguishable from a point and the picture will be acceptably sharp.

Cold-tone developer. Paper developer that gives a blue-black color to the image on the photographic paper.

Color cast. An overall tint in an image, caused by light sources that do not match the sensitivity of the film, by reciprocity failure, or by poor storage or processing.

Color temperature. A system for measuring the color quality of a light source by comparing it to the color quality of light emitted when a theoretical black body is heated. Color temperature is measured in degrees Kelvin.

Coma. A lens aberration causing blurring at the edge of the image.

Combination printing. The technique of sandwiching two negatives together and then printing them.

Complementary colors. A pair of colors that, when mixed together by the additive process, produce white light.

Condenser. A simple, one-element lens found in enlargers and used to converge the light and focus it on the back of the enlarger lens.

Contact print. A print created by placing the negative(s) in direct contact with the printing paper. No enlarger lens is necessary.

Continuous tone. Reproducing or capable of reproducing a range of tones from pure black to pure white.

Contrast. The difference between tones in an image.

Contrast grade. A number indicating the contrast level produced by a particular photographic paper. The higher the grade on a scale of 0 to 5, the greater the contrast of the paper.

Cookie. A shading device made of a translucent material to give a mottled distribution of light.

Copper toning. Adding a warm, reddish-brown color to a print by using a copper-based toner. The long-term stability of a copper-toned print is not good.

Cropping. Selecting a portion of an image for reproduction in order to modify the composition.

Cyan. A blue-green color, the complement of red; one of the three subtractive primary colors.

D log E curve. A characteristic curve for a photographic emulsion, indicating the relationship of the density of the emulsion to the log of the exposure.

Density. The ability of a developed silver deposit on a photographic emulsion to block light. The greater the density of an area, the greater its ability to block light and the darker its appearance.

Densitometer. An instrument for measuring density.

Density range. The difference between the minimum density of a print or film and its maximum density.

Depth of focus. The distance the film plane can be moved while still maintaining acceptable focus, without refocusing the lens.

Developer. A chemical solution that changes the latent image on exposed film or paper into a visible image.

Diaphragm. *See* Aperture

Diffraction. The scattering of light waves as they strike the edge of an opaque material.

Diffused image. An image that appears to be soft and has indistinct edges, generally created by shooting or printing with a diffusing device.

Diffused light. Light that produces soft outlines and relatively light and indistinct shadows.

Diffuser. A translucent material that scatters light passed through it.

Diopter. A measurement of the refractive quality of a lens. Usually used in connection with supplementary close-up lenses to indicate their degree of magnification.

Dodging. The technique of giving less exposure to selected parts of an image during printing.

Double exposure. The exposure of two different images on a single piece of film.

Drying marks. Marks occasionally left on processed film after it dries. They can be avoided by use of a wetting agent and removed by careful rewashing.

Easel. A frame for holding printing paper flat during exposure.

Electronic flash. A short, bright artificial light produced by passing electricity across two electrodes in a gas-filled glass chamber.

Emulsion. A light-sensitive layer of silver halide salts suspended in gelatin and coated onto a paper or film base.

Enlargement. A print made from a smaller negative.

Enlarger. A device used to project and enlarge an image of a negative onto photographic paper or film.

Exposure. The amount of light allowed to reach a photographic emulsion.

Exposure factor. *See* Filter factor

Exposure latitude. The maximum change in exposure from the ideal exposure that will still give acceptable results.

Exposure meter. An instrument designed to indicate the amount of light either falling on or reflected by the subject.

Extension rings or tubes. Rings or short tubes that fit between the body and lens of a camera, designed to increase the focal length of the lens for close-up work.

Farmer's reducer. A solution, consisting of hypo (sodium thiosulphite) and potassium ferricyanide, used to lighten all or part of a black-and-white negative or print.

Fill flash. A flash unit used to supplement the existing light, particularly outdoors.

Fill light. A supplemental light used to reduce shadows and contrast caused by a main light.

Filter factor. The increase in exposure needed when filters are placed in front of the lens.

Fixer. A chemical solution that dissolves the remaining silver halides in an image, making it permanent.

Flag. A square or rectangular reflector attached to a stand.

Flare. Stray light, not part of the image, that reaches the film in the camera because of scattering and reflection within the lens.

Flatness. Lack of contrast in an image, caused by overly diffuse light, underdevelopment or underexposure, or flare.

Floodlight. A tungsten light and reflector.

Focal length. The distance between the center of a lens and the film when the lens is focused at infinity.

Focal plane. The plane behind the lens where the sharpest image from the lens falls; the plane of the film.

Fog. Density on a photographic emulsion

caused by accidental exposure to light or by processing chemicals and not part of the photographic image.

Fogging. In the camera, deliberately exposing the film to unfocused light, either before or after photographing a subject, in order to reduce contrast. In the darkroom, a usually accidental development of the film or paper because of something other than exposure (e.g., chemical contaminants).

Fresnel lens. A thin condenser lens with a number of concentric ridges on it, used to distribute brightness evenly in spotlights and viewing screens.

Fresnel screen. A viewing screen incorporating a Fresnel lens.

Front element. In a lens, the piece of glass furthest from the film plane.

Gamma. A number, derived from the steepness of the straight-line portion of the characteristic curve of an emulsion, indicating the degree of development the emulsion has received. The more development the film has received, the higher the value of gamma and the greater the contrast.

Gelatin. The substance in an emulsion in which the light-sensitive particles of silver halide are suspended.

Gelatin filters. Colored filters that provide strong overall color effects.

Glossy paper. An extremely smooth type of photographic paper giving a great range of tones from pure white to pure black.

Gobo. A flat, black flag, usually a small circle or square, used to block or direct the light from a photo lamp.

Gradation. The range of tones, from white to black, found in a print or negative.

Grade. The measurement of the degree of contrast of a photographic paper, usually on a scale of 0 to 4.

Gray scale. A series of patches, joined together, of shades of gray ranging from white to balck in equal increments.

Ground glass. A sheet of glass ground to a translucent finish, used for focusing.

Guide number. A number on an electronic flash unit indicating its power.

H & D curve. A performance curve for a photographic emulsion, named for Hurter and Driffield, its developers and pioneers in the field of sensitometry.

Halation. The undesirable effect created when light passes through an emulsion, strikes the backing, and is reflected back through the emulsion, reexposing it.

Hardener. A chemical, usually incorporated into the fixer, that causes an emulsion to harden while drying, making it less susceptible to damage.

High-contrast paper. Photographic printing paper with a great deal of contrast, generally about grade 4.

Highlight mask. An intermediate positive or negative created to retain the highlights when duplicating.

Highlights. The areas of a photograph that are only barely darker than pure white.

Hot spots. A part of a scene or photograph that is relatively over-lit, often caused by poor placement of lights.

Hue. The name of a color.

Hyperfocal distance. When a lens is focused at infinity, the minimum distance at which it will record a subject sharply.

Hypo. Another name for sodium thiosulfate or fixer.

Hypo clearing bath (eliminator). A chemical solution used to shorten the washing time needed after fixing.

Illumination. The amount of light falling on a subject.

Incident light meter. A light meter used to measure the light falling on the subject.

Infrared film. Film sensitive to the infrared end of the spectrum, beyond the light visible to the human eye.

Intensifier. A chemical used to add density or contrast to a negative that is too thin for satisfactory printing.

Inverse square law. The principle that the amount of light falling on a subject varies in relation to the square of the distance between the light source and the subject.

Iron-blue toning. Adding a brilliant blue color to a print by using an iron-based toner.

Kelvin. The unit used to measure color temperature; the Celsius temperature plus 273.

Keystoning. A distortion of perspective that makes parallel lines appear to converge as they recede in the photograph.

Latitude. The amount of over- or underexposure a photographic emulsion can receive and still produce acceptable results.

Light cone. A cone made of a translucent material and used to diffuse evenly the light falling on the subject.

Light tent. A tent made of a translucent material, designed to be placed over the subject to provide shadowless, diffuse light.

Lighting ratio. A comparison of the amount of light falling on one side of the subject with the amount falling on the other side.

Line print. An outline effect created by sandwiching a positive and negative Kodalith of the same image and then making the print by passing light through the sandwich at a 45-degree angle.

Lith developer. A developer designed specifically for lith films.

Lith film. A very high-contrast film emulsion used for a number of darkroom special effects; Kodalith is the best-known brand.

Lumen. The amount of light reaching one square foot of a surface one foot from a light emitting one candela of intensity. The standard unit of measurement of luminance.

Luminance. The brightness of a light.

Mackie lines. In solarization or the Sabattier effect, the clear, undeveloped lines created where the positive and negative parts of the image meet.

Macro lens. A lens capable of very close focusing without supplementary close-up lenses, and usually capable of producing a 1:1 image on the film.

Macro photography. Photography that produces images generally ranging from one-half to ten times life-size. Images larger than ten times life-size are usually created by photography through a microscope.

Magenta. One of the three subtractive primary colors; the others are cyan and yellow.

Mask. A device used to modify or hide part of an image during printing.

Matte. A descriptive term for any surface that is relatively nonreflective.

Mid-range. Those tones in a scene that fall midway between the darkest and lightest tones.

Mired. A measurement of color temperature used to find the difference between light sources and calculate the effect of color filters.

Modeling light. A small spotlight that can be precisely directed.

Montage. A composite picture made by combining elements from different photographs together.

Motor drive. A device used to advance film automatically through the camera, often at greater speeds and with more versatility than an autowinder.

Munsell system. A systematic method of color classification based on the three dimensions of color: hue (the name of the color), value (its lightness), and chroma (its saturation).

Neutral density filter. A filter, available in varying intensities, that reduces the amount of light reaching the film without affecting its color.

Negative carrier. A holder used to position the negative correctly between the enlarger light and the enlarger lens.

One-shot solution. Any processing solution designed to be used once and then discarded.

Opaquing. 1. The technique of covering parts of a negative with an opaquing solution to block out the image in that area. 2. To fill in pinholes in Kodalith negatives or positives with an opaquing solution.

Orthochromatic. An emulsion, either paper or film, that is sensitive to green, blue, and ultraviolet light and can be handled under a dark red safelight.

Overdevelopment. Development for longer than the recommended time.

Overexposure. Exposure for longer than the recommended time.

Panchromatic. Sensitive to all the colors of the visible spectrum.

Panning. Moving the camera to follow a moving subject and keep it continuously in the viewfinder.

Parallax. Of particular importance when using non-SLR cameras, parallax is the apparent movement of objects relative to each other when seen from different places.

Photoflood. A tungsten light with a color temperature of 3400° K.

Polarized light. Light that vibrates in only one plane rather than many.

Polarizing screen. A rotating filter attachment that allows light vibrating in only one plane to pass through the lens.

Posterization. A high-contrast printing procedure producing a print with only two or three (sometimes more) tones.

Primary colors. Any three colors that can be combined to make any other color. In additive color, the primary colors are red, green, and blue; in subtractive color, the primary colors are yellow, magenta, and cyan.

Printing frame. A frame used to hold the negative and paper together when exposing a contact print.

Pull processing. Intentional under-development of a film or paper, usually because it has been overexposed.

Push processing. Intentional over-development of a film or paper, usually because it has been underexposed.

Quartz-halogen lamp. A tungsten-balanced photo light that burns brightly and evenly with consistent color temperature over a long period.

Reciprocity failure. During very long or very short exposures, the law of reciprocity no longer holds and film shows a loss of sensitivity, resulting in underexposure, and color changes in the case of color film.

Reciprocity law. The amount of exposure a film receives is the product of the intensity of the light (aperture) times the exposure time (shutter speed). A change in one is compensated for by a change in the other.

Reducer. A chemical solution used to reduce the density of a negative or print.

Reflected-light reading. A light reading taken by pointing the meter at the subject and measuring the light reflected from it.

Reflector. Any surface used to direct light onto or near the subject.

Replenisher. A solution added to a larger amount of the same solution to maintain its strength as it is depleted by use.

Resin-coated (RC) paper. Photographic printing paper with a plastic backing. RC paper dries quickly without curling.

Reticulation. A crazed pattern of cracks in the photographic emulsion, caused by a sudden change of temperature during processing.

Reversing rings. Adapters enabling the camera lens to be reversed and mounted for close-up work.

Rising front or standard. On a view camera, a lens panel that can be moved up or down.

Sabattier effect. The appearance of areas of both a positive and negative image on a film or paper, caused by brief exposure to light during development.

Safelight. A colored light that does not affect the photographic material in use. E.g., a dark red light used when processing orthochromatic film.

Saturation. The purity of a color; the more white light the color contains, the less saturated it is.

Scrim. A translucent material used to diffuse light shining through it.

Selenium toning. Adding a rich brown tone to a print by using a toner containing selenium.

Sensitometry. The exact measurement of the sensitivity of film and paper.

Sepia toning. Adding a brown or sepia color to a print by using a sulphide-based toner. Sepia toning adds interest and permanence to a print.

Silver halides. A general name for a group of light-sensitive chemicals used in photographic emulsions.

Skylight filter. A filter used to absorb excess ultraviolet radiation.

Snoot. A conical attachment for a photo light used to concentrate the light into a small, circular area.

Soft box. A light with built-in reflectors, giving diffuse light with soft shadows.

Soft-focus lens. A lens designed to give an image that is less than sharp and is slightly diffused.

Solarization. The creation of a combination

of a partially positive and negative image when a negative is greatly overexposed.

Split-focus lens. A lens attachment that is clear glass on one half and a plus-diopter close-up lens on the other, allowing a close foreground and a distant background to both be in focus.

Spotlight. A light source that gives a concentrated beam of light producing sharp shadows.

Spot meter. A hand-held exposure meter with a very narrow angle of view, used for measuring reflected light at a specific point.

Stock solution. Any processing solution that can be premixed and stored for later use in lesser amounts.

Stop bath. A chemical solution used to end the action of a developer.

Strobe light. An electronic flash unit.

Strobe meter. A flash exposure meter.

Sweep table. A table with a surface of translucent plastic that can be lit from underneath.

Swings. Horizontal movements on the front and rear standards of a view camera.

Target. A small, circular gobo.

Test strip. A series of different exposures on a single piece of paper or film, used to find the optimal exposure.

Tilts. Vertical movements of the front and rear standards of a view camera.

Tonal deletion. The elimination of shades of gray from a print, producing a high-contrast print using only black and white.

Tonal range. The gradations of gray between the darkest and lightest areas of a print or scene.

Toner. A chemical that adds color to or changes the color of a black-and-white print or negative.

Tone separation. *See* Posterization

Tungsten light. A lightbulb containing a tungsten filament and giving light with a color temperature of about 3200° K.

Ultraviolet filter. *See* Skylight filter

Ultraviolet radiation. Invisible energy just below the short-wavelength end of the visible spectrum, and present in many light sources.

Variable-contrast paper. Black-and-white printing paper that gives a range of contrast grades, depending on the filtration used in enlarging.

View camera. A large-format camera with movable front and rear standards joined by a bellows.

Vignetting. Darkening in the corners of an image, caused by the instrusion of the lens hood or filter into the subject area.

Warm-tone developer. Paper developer that gives a brown-black color to the image on the photographic paper.

Wetting agent. A chemical added to the last processing wash to ensure even drying.

Yellow. One the primary additive colors.

Zone System. A method for converting light measurement into exposure settings by analyzing the tonal range of the subject and dividing it into numbered zones.

Index